Enchanting the Eye

DUTCH PAINTINGS OF THE GOLDEN AGE

Enchantin

the Eye

DUTCH PAINTINGS OF THE GOLDEN AGE

CHRISTOPHER LLOYD

ROYAL COLLECTION PUBLICATIONS

This publication has been supported by KPMG.

Published by
Royal Collection Enterprises Ltd
St James's Palace, London SW1A 1JR
For a complete catalogue of current publications, please
write to the address above, or visit our website on
www.the-royal-collection.com

© 2004 Royal Collection Enterprises Ltd
Text by Christopher Lloyd and reproductions
of all items in the Royal Collection
© 2004 HM Queen Elizabeth II

127944

ISBN 1 902163 90 7

British Library Cataloguing in Publication Data:
A catalogue record for this book is available from
the British Library.

Designed by Mick Keates
Produced by Book Production Consultants plc, Cambridge
Printed and bound by Graphic Studio, Verona

Front cover: Johannes Vermeer, *A lady at the virginals
with a gentleman* ('The Music Lesson'),
c.1662–5.

Back cover: Wlllem van de Velde the Younger,
*A calm: a States yacht under sail close to the shore,
with many other vessels, c*.1655

Title pages: Wlllem van Mieris,
The Neglected Lute (detail), *c*.1708

PICTURE CREDITS

All works reproduced are in the Royal Collection unless
indicated otherwise below. Royal Collection Enterprises are
grateful for permission to reproduce the following:

Adriaan de Lelie, *The art gallery of Jan Gildemeester Jansz*
(A4100), Rijksmuseum, Amsterdam (p.16)

Pieter Jansz. Saenredam, *Interior of St Bavo's Church*
(NG 2413), National Gallery of Scotland, Edinburgh (p.20)

Gerrit Dou, *The Young Mother*,
Royal Cabinet of Paintings, Mauritshuis, The Hague (p.21)

Hans Memlinc, *The Virgin and Child with Saints
and Donors* ('The Donne Triptych')
(NG6275.1), ©The National Gallery, London (p.23)

Henri Matisse, *Still life after Jan Davidsz. de Heem's
'La Desserte'*,
The Museum of Modern Art, New York. Gift and Bequest
of Florene M. Schoenborn and Samuel A. Marx.
Digital Image © 2004 The Museum of Modern Art,
New York (p.28)

Piet Mondrian, *Composition 10 (Pier and Ocean)*
Collection Kröller-Müller Museum, Otterlo (p.29)

Joseph Mallord William Turner, *Dutch boats in a gale*
('The Bridgewater Sea Piece') (NGL297), Private Collection
on loan to the National Gallery, London (p.30)

Jan de Bray, *The Banquet of Antony and Cleopatra*,
Currier Museum of Art, Manchester, New Hampshire.
Museum Purchase: Currier Funds, 1969.8 (p.52)

Jacob van Ruisdael, *Landscape with watermill*
(C213), Rijksmuseum, Amsterdam (p.78)

Nicolaes Maes, *The Listening Housewife*
(P224), by kind permission of the Trustees of the Wallace
Collection, London (p.94)

Gabriel Metsu, *The Letter Writer Surprised*
(P240), by kind permission of the Trustees of the Wallace
Collection, London (p.97)

Maria van Oosterwyck, *Vanitas still life*
(GG 5714), Kunsthistoriches Museum, Wien oder KHM,
Vienna (p.112)

Jan Steen, *Woman at her toilet* (A4052), Rijksmuseum,
Amsterdam (p.155)

Adam Willaerts, *Embarkation of the Elector Palatine
in 'The Royal Prince'*
(BHC0266), ©National Maritime Museum, London (p.181)

Thomas Gainsborough, *Landscape with a view
of Cornard village*
(NG 2174), National Gallery of Scotland, Edinburgh (p.192)

Every effort has been made to contact copyright holders;
any omissions are inadvertent, and will be corrected in
future editions if notification of the amended credit is sent
to the publisher in writing.

CONTENTS

THE CRITICAL EYE: DUTCH PAINTINGS OF THE GOLDEN AGE

… the eyes, which, in their eager sweep over all the beauties in Pictura's courts, seek many places in which to amuse themselves, wherever it pleases their desire to lead them, hungering to see more above and below, tasting all manners of delicious nectars…

Karel van Mander, *Het Schilder-boeck* (*The Painter's Book*) (1604)

Good pictures are very common here, there being scarce an ordinary tradesman whose house is not adorned with them…

William Aglionby, *The Present State of the Low Countries* (1669)

If you come this way, as I did, chiefly with an eye to Dutch pictures, your first acquisition, is a sense, no longer an amiable inference, but a direct perception, of the undiluted accuracy of Dutch painters. You have seen it all before; it is vexatiously familiar; it was hardly worth while to have come! At Amsterdam, at Leyden, at The Hague, and in the country between them, this is half your state of mind. When you are looking at the originals, you seem to be looking at the copies; and when you are looking at the copies, you seem to be looking at the originals. Is it a canal-side in Haarlem, or is it a Van der Heyden? Is it a priceless Hobbema, or is it a meagre pastoral vista, stretching away from the

railway-track? The maid-servants in the streets seem to have stepped out of the frame of a Gerard Dow, and appear equally adapted for stepping back again. You have to rub your eyes to ascertain their normal situation. And so you wander about, with art and nature playing so assiduously into each other's hands that your experience of Holland becomes something singularly compact and complete in itself – striking no chords that lead elsewhere, and asking no outside help to unfold itself. This is what we mean when we say, as we do at every turn, that Holland is so *curious* . . .

The beauty which is no beauty; the ugliness which is not ugliness; the poetry which is prose, and the prose which is poetry; the landscape which seems to be all sky until you have taken particular pains to discover it, and turns out to be half water when you *have* discovered it; the virtues, when they are graceful (like cleanliness) exaggerated to a vice, and when they are sordid (like the getting and keeping of money) re-fined to a dignity; the mild gray light which produced in Rembrandt the very genius of chiaroscuro; the stretch of whole provinces on the principles of a billiard-table, which produced a school of consummate landscapists; the extraordinary reversal of custom, in which man seems, with a few windmills and ditches, to do what he will, and Providence, holding the North Sea in the hollow of his hand, what it can – all these elements of the general spectacle in this entertaining country at least give one's regular habits of thought the stimulus of a little confusion, and make one feel that one is dealing with an original genius.

Henry James, 'In Holland, The Hague, August 8, 1874',
Transatlantic Sketches (1875)

What struck me most on seeing the old Dutch pictures again is that most
of them *were painted quickly*, that these great masters, such as a Frans Hals,
a Rembrandt, a Ruysdael and so many others – dashed off a thing from
the first stroke and did not retouch it so very much…
I think a great lesson taught by the old Dutch masters is the following:
to consider drawing and colour one…

Vincent van Gogh, letter to his brother Théo, October 1885

These days my thoughts are full of Rembrandt and Hals all the time,
not because I see so many of their pictures, but because among the
people here I see so many types that remind me of that time.

Vincent van Gogh, letter to his brother Théo, 28 December 1885

The thought that struck me after I had seen not only the Rembrandts,
but the works of Franz Hals, Vermeer and so many other great artists, was that
we modern painters, we are unassailably correct to seek where they did not
or rather to feel differently from the way they did, since different we are,
and their works are so definitely of their time that it would be absurd to
follow them…The paintings by Hals, and the *View of Delft* by Vermeer, are
masterpieces akin to the works of the impressionists. I returned from
Holland more persuaded than ever to love Monet, Degas, Renoir, Sisley…

Camille Pissarro, letter to his eldest son Lucien, November 1898

My love for plane geometry prepared me to feel a special affection for Holland. For the Dutch landscape has all the qualities that make geometry so delightful. A tour in Holland is a tour through the first books of Euclid. Over a country that is the ideal plane surface of the geometry books, the roads and the canals trace out the shortest distances between point and point. In the interminable polders, the road-topped dykes and gleaming ditches intersect with one another at right angles, a criss-cross of perfect parallels. Each rectangle of juicy meadowland contained between the intersecting dykes has identically the same area.

Aldous Huxley, *Along the Road. Notes and Essays of a Tourist* (1925)

Were we to test the average Dutchman's knowledge of life in the Netherlands during the seventeenth century, we should probably find that it is largely confined to odd stray notions gleaned from paintings. … the basis of seventeenth-century Dutch culture was urban society. Within it, cultural creation was singularly independent of rank or wealth. In the great task of encouraging new art forms and expressing new ideas, the patricians and members of the learned professions – lawyers, doctors, clergymen – worked hand in hand, almost fraternally. Even the deep gulf between Protestants and Catholics did not preclude individuals from co-operating in this task…
… The modern art-lover must be careful to avoid the temptation of looking at the painter's ideas or subjects in the light of his own views and hence seeing more in them than was there…
… Part of their art will forever elude us. It is full of arcane allusions and many of these we cannot hope to fathom even after the most careful research…

J.H. Huizinga, *Dutch Civilisation in the Seventeenth Century* (1941)

The aim of Dutch painters was to capture on a surface a great
range of knowledge and information about the world…
 There is in Dutch painting a pleasure taken in description that
is akin to what we find in the world of maps.

Svetlana Alpers, *The Art of Describing. Dutch Art
in the Seventeenth Century* (1983)

 We end, then, where we began: in the moral geography of the Dutch mind,
adrift between the fear of the deluge and the hope of moral salvage, in the tidal
ebb and flow between worldliness and homeliness, between the gratification
of appetite and its denial, between the conditional consecration of wealth and
perdition in its surfeit. By the very nature of things, in a little land that had
become, to its own surprise, the arbiter of the world, there could be no
reconciliation of these dilemmas… To be Dutch, as the indeterminate quality
of the habitat always reminded them, was to live in a perpetual present
participle, to cohabit with the unsettled. But while historical circumstances
changed from generation to generation, the perennial resurrection of these
dilemmas was itself some sign of continuity. To be Dutch still means coming
to terms with the moral ambiguities of materialism in their own idiosyncratic
but inescapable ways: through the daily living of it, in Sunday sermons on
nuclear weapons and Monday rites of scrubbing the sidewalk.

Simon Schama, *The Embarrassment of Riches. An Interpretation of Dutch Culture
in the Golden Age* (1987)

CHRONOLOGY OF ARTISTS' DATES

Adam Willaerts 1577–1664

Hendrich Pot c.1580–1657

Frans Hals c.1582/3–1666

Hendrick ter Bruggen 1588–1629

Willem Claesz. Heda 1593/4–1680/2

Cornelis van Poelenburgh
1594–1667

Gerrit Houckgeest c.1600–1661

Salomon van Ruysdael
c.1600/3–1670

Rembrandt van Rijn 1606–1669

Jan Miense Molenaer c.1610–1668

Adriaen van Ostade 1610–1685

Frans Post c.1612–1680

Gerrit Dou 1613–1675

Ludolf de Jongh 1616–1679

Gerard ter Borch 1617–1681

Philips Wouwermans 1619–1668

Nicolaes Berchem 1620–1683

Aelbert Cuyp 1620–1691

Isaac van Ostade 1621–1649

Johannes Lingelbach 1622–1674

Jan Steen 1626–1679

Jan de Bray c.1627–1697

Barent Graat 1628–1709

Gabriel Metsu 1629–1667

Pieter de Hooch 1629–1684

Maria van Oosterwyck 1630–1693

Jan Wynants 1631/2–1684

Johannes Vermeer 1632–1675

Willem van de Velde the Younger
1633–1707

Nicolaes Maes 1634–1693

Frans van Mieris the Elder
1635–1681

Adriaen van de Velde 1636–1672

Jan van der Heyden 1637–1712

Meyndert Hobbema 1638–1709

Jan Weenix 1642–1719

Godfried Schalcken 1643–1706

Adriaen van der Werff 1659–1722

Willem van Mieris 1662–1747

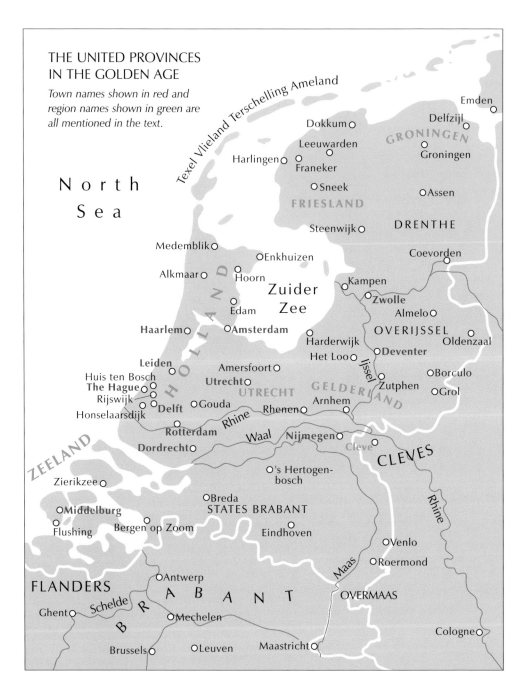

THE UNITED PROVINCES
IN THE GOLDEN AGE

*Town names shown in red and
region names shown in green are
all mentioned in the text.*

North
Sea

Texel Vlieland Terschelling Ameland

Dokkum

Leeuwarden

Harlingen
Franeker

GRONINGEN

Emden

Delfzijl

Groningen

Sneek

Assen

FRIESLAND

Steenwijk

DRENTHE

Medemblik

Enkhuizen

Coevorden

Alkmaar
Hoorn

Kampen

Zuider
Zee

Zwolle

Almelo

Edam

Haarlem
Amsterdam

OVERIJSSEL

Oldenzaal

Harderwijk

Het Loo

Deventer

HOLLAND

Leiden

Amersfoort

Huis ten Bosch
The Hague
Rijswijk

Utrecht

Borculo

Zutphen

Grol

UTRECHT

GELDERLAND

IJssel

Delft
Gouda

Rhenen

Arnhem

Honselaarsdijk

Rotterdam

Rhine

ZEELAND

Zierikzee

Waal

Nijmegen

Cleve

CLEVES

Dordrecht

's Hertogen-
bosch

Middelburg

Breda

STATES BRABANT

Flushing

Bergen op Zoom

Eindhoven

Venlo

Roermond

Rhine

FLANDERS

Antwerp

BRABANT

OVERMAAS

Ghent

Schelde

Maas

Mechelen

Cologne

Brussels

Leuven

Maastricht

INTRODUCTION: THE HISTORICAL BACKGROUND AND DUTCH PAINTINGS IN THE ROYAL COLLECTION

The art of seventeenth-century Holland was the product of a particular set of circumstances. Like the Italian Renaissance before it, the Dutch Golden Age was initiated by a blending of politics, economics and cultural aspiration. Since the sixteenth century, the seventeen provinces forming The Netherlands had been ruled by Spain as part of the Habsburg Empire, but the resistance set in motion by William the Silent (1533–84) eventually led to a split between the northern and southern provinces. In 1579 the seven northern provinces – Holland, Zeeland, Utrecht, Gelderland, Overijssel, Friesland and Groningen – formed a confederation called the United Provinces, thus breaking away from Spanish domination (see map). This was formally acknowledged in 1609, but not legally ratified until the Treaty of Münster in 1648.

These northern provinces coincide with The Netherlands of today, known colloquially as Holland. The southern provinces remained under Spanish rule and in time became modern Belgium. The separation between the northern and southern provinces was not solely a political matter. Religious differences were also important, with the northern provinces being influenced by the Reformation and allowing a greater degree of toleration for different religious groups – Calvinists, Lutherans, Catholics, Mennonites, Jews. By contrast, in the southern provinces Catholicism continued to hold sway.

These developments were in turn reflected in the system of government adopted in the northern provinces. Each province remained autonomous and elected its own stadtholder, and each sent representatives to the States-General that met in The Hague and determined foreign policy. The States-General appointed an overall Stadtholder, a position with which members of the House

of Orange, descended from the counts of Nassau, were often – but not uniquely – associated. For a crucial period (1652–73), there was no Stadtholder and the United Provinces were governed by Johan de Witt (1625–72), a representative from the province of Holland. His downfall was triggered by the invasion of Louis XIV (1638–1715) of France, who was ultimately defeated by the next Stadtholder, Willem III (later William III of England; 1650–1702). The Stadtholder served as leader, usually in times of military crisis, but in all other respects he was answerable to the States-General. A ruling class of regents, whose wealth was often made as a result of commercial success, soon asserted itself, but essentially society in seventeenth-century Holland was remarkably open, as is most evident from organisations like the militia companies depicted by Rembrandt and Frans Hals. Only in the second generation or after did wealth become translated into the acquisition of landed estates or the proliferation of buildings of personal significance. The main internal political tension in the northern provinces was between the representatives of the States-General safeguarding their civic rights against the ambitions of the Orange family.

Once formed, the northern provinces revelled in their independence. The establishment of sea-power, the concomitant expansion in trade and a thriving empire helped to create and define a national identity, but not at the cost of individual loyalty to local provinces. The sea was the single most powerful motivating force in Dutch life. Trade was the basis of the economy and geography gave the United Provinces a distinct advantage. To use Simon Schama's winning metaphor, 'The Republic was an island of plenty in an ocean of want.' The two great rivers, the Rhine and the Maas, provided easy access to the global market as well as to the heart of Europe; and also, internally, the close proximity of towns and the intricate network of canals made for great mobility within the country and a corresponding increase in turnover. Equally, on the western side of the country, the sea could be a threat and the danger of flooding was ever present so that a system of dykes and a policy of land reclamation were a permanent necessity. What land became available in this area was intensely farmed or developed for horticulture and, although subject to wider economic

forces, rural society flourished. Amsterdam had become the entrepôt of Europe, and Antwerp in the southern provinces was eclipsed. Dutch art was very much a reflection of this freshly created world.

In the words of Professor Jonathan Israel, 'it was a society in which no one could live without continually sensing the interaction of land and sea, town and country, one town with the next, soldiers and seamen with burghers, the exotic with the mundane, and the foreign with the local. Art, by encompassing all of this, and repeating it on everyone's walls, and in every tavern and public building, made explicit, and heightened awareness of what everyone saw and felt.' To that extent the art of the Golden Age was the way in which the United Provinces saw itself. More traditional forms of painting – mythological and religious – were not ignored, but they were not given such prominence and even history painting, which was able to serve a specific purpose in the new Republic in the decoration of civic buildings, looked slightly out of place.

Self-confidence at home and success overseas, a buoyant economy and an expanding population are just the right ingredients for art to flourish. The period from the 1590s through to the end of the seventeenth century (apart from when a loss of confidence was created by the French invasion in 1672) was one, according to Professor Israel, 'in which artistic achievement and innovation in art proceeded on a scale, and with an intensity, which has no parallel in any other time, or place, in history'. An extrapolated figure provides an estimate of some 1.3 and 1.4 million pictures in Holland produced by between 650 and 750 painters for the period 1640–59 alone. For the longer period of 1580–1800 an estimate of 5,000 painters producing between 9 and 10 million paintings has been suggested. Probably only 10 per cent of these were of real quality and fewer than 1 per cent survive today, but it was then a huge market to which should be added items from the decorative arts and more public manifestations of patronage involving buildings and sculpture.

After the financial difficulties encountered as a result of the French invasion of 1672 there was a falling off in demand and the art market virtually collapsed – a state of affairs that continued until the end of the century. Fewer artists were

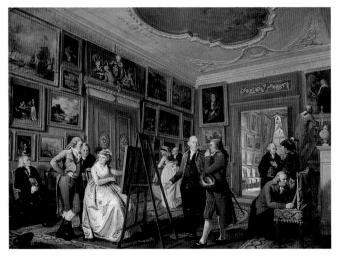

1. Adriaan de Lelie,
*The art gallery of Jan
Gildemeester Jansz.
in his house on the
Herengracht,
Amsterdam*, 1794–5
(Rijksmuseum, Amsterdam)

Jan Gildemeester (1744–99),
a wealthy merchant based
in Amsterdam, owned an
outstanding collection of
Dutch and Flemish paintings.
Several of his pictures were
eventually acquired by
George IV.

being trained and those already fully fledged were less productive, as in the
cases, for example, of Pieter de Hooch, Johannes Vermeer, Nicolaes Berchem,
Meyndert Hobbema and Jacob Ochtervelt (1634–82). Vermeer's widow testified
that 'her husband during the war with the king of France, and the next years,
had been able to earn very little, or almost nothing, so that the works of art
which he had previously bought, and in which he dealt, had had to be sold off,
at very great loss, to feed their children'. It does not necessarily follow that there
was a lowering of quality, although that has sometimes been argued, but it is true
that by the start of the eighteenth century the Golden Age of Dutch art had
passed. Significantly, it was just at this moment that the first major appraisal of
Dutch art, published in 1718–21, was undertaken by Arnold Houbraken
(1660–1719) and it was also when great collections of Dutch seventeenth-
century art began to be formed in Holland, France and Britain (fig. 1).

Patronage was focused on urban centres. At the beginning of the Golden Age
Haarlem and Utrecht took the lead, followed later by Amsterdam, Leiden and
Delft; but other places such as Dordrecht, Rotterdam, Zwolle, Deventer and
Middelburg also played significant roles. The competition between them was
healthy and created extra vitality, although artists did frequently move from one

centre to another. The fact that patronage tended to be so narrowly focused – there was little centralised state patronage as such – meant that local institutions such as the Guild of St Luke to which artists belonged were given greater prominence. Artists often became closely associated with single places – Gerrit Dou and Jan Steen with Leiden, Gerard ter Borch (fig. 2) with Deventer, Frans Hals and Jacob van Ruisdael (1628/9–82) with Haarlem, de Hooch and Vermeer with Delft, Rembrandt with Amsterdam, Adriaen van der Werff with Rotterdam and Aelbert Cuyp with Dordrecht. Similarly, some of these artists specialised in specific styles or types of painting that gave distinction to particular places: certain painters from Haarlem were influenced by the style of Caravaggio

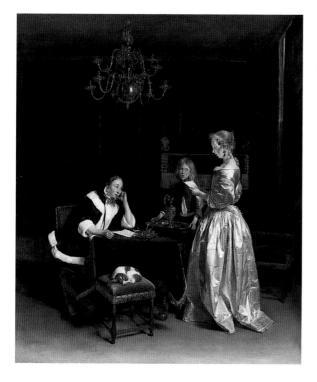

2. Gerard ter Borch,
The Letter, c.1660–62
(RCIN 405532)

One of the artist's finest paintings, which belonged to Jan Gildemeester and can be seen on the left of fig. 1.

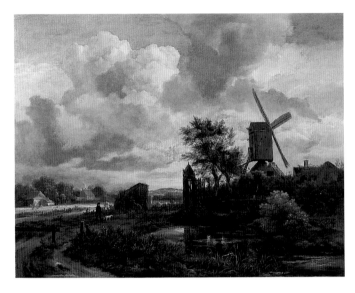

Left:
3. Jacob van Ruisdael,
*Evening landscape: a
windmill by a stream*,
c.1646 (RCIN 405538)

This landscape, which was
acquired by George IV, was
particularly admired by John
Constable when he saw it
on public view in 1821.

Below:
4. Aelbert Cuyp,
The Passage Boat,
c.1650 (RCIN 405344)

One of the artist's most
majestic views of shipping
in the harbour of Dordrecht,
forming part of the prestigious
collection of Dutch paintings
assembled by the banker
Sir Francis Baring and his
son Sir Thomas Baring.
The collection was acquired
by George IV in 1814.

Right:
5. Rembrandt van Rijn,
*Portrait of Jan Rijcksen
and his wife, Griet Jans
('The Shipbuilder and
his Wife')*, 1633
(RCIN 405533)

An important early double-
portrait by the artist that
helped to establish his
reputation in Amsterdam.
It too belonged to Jan
Gildemeester (see fig. 1).

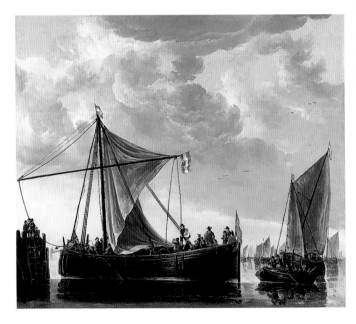

(1573–1610) and his followers; Leiden under the leadership of Dou produced painters who worked in a meticulous, highly finished style and so became known as the *fijnschilders* (fine painters); Haarlem basked in the reflected glory of a portrait painter of the calibre of Hals, a landscape painter of the genius of Jacob van Ruisdael (fig. 3) and a recorder of peasant life with the skill of Adriaen van Ostade; Delft nurtured observers of the daily scene as gifted as de Hooch and as enigmatic as Vermeer; Dordrecht inspired Cuyp to paint majestic views of its port (fig. 4) and was also where he painted his imaginary landscapes bathed in a golden light. Only Amsterdam, the most cosmopolitan city in northern Europe, lacked the artistic cohesion that these smaller places had, but it was there, nonetheless, that artists went to establish a reputation or to find a commercial outlet for their work – thus it was where Rembrandt (fig. 5) chose to live.

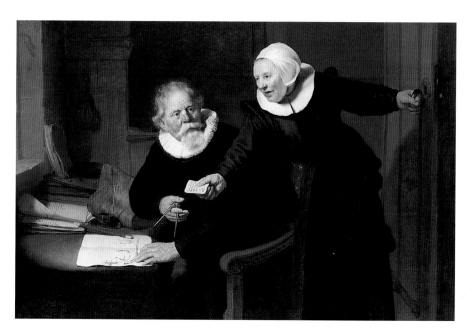

Civic pride was at its height during the 1650s and 1660s and manifested itself principally in the building of town halls and churches or the carving of sculptured monuments, but there was also a tendency for patrons to collect works by local painters. The principal collectors of works of art were the regent and the merchant classes, either for their town houses or for their rural retreats, but the local Guilds of St Luke sometimes limited the number of sales that could be made outside a certain town. A large number of Vermeer's paintings – almost two-thirds of his oeuvre – remained in Delft in the collection of his wealthy patron Pieter Claesz. van Ruijven (1624–74). Likewise, collectors in Dordrecht acquired extensive groups of works by Cuyp; and in Leiden Johan de Bye and François de la Boe Sylvius (1614–73) accumulated numerous paintings by Dou. Conversely, it is true to say that artists were closely integrated into local society by belonging not just to the relevant Guild of St Luke, but also to militias and chambers of rhetoric (*Rederijkerskamers*).

The success of Dutch seventeenth-century painters was by no means limited to the United Provinces. At the very beginning of his career, with the support of the polymath Constantijn Huygens (1596–1654), who was secretary and then adviser to several stadtholders, the young Rembrandt began to sell his work to overseas

6. Pieter Jansz. Saenredam, *Interior of St Bavo's Church, Haarlem*, 1648

(National Gallery of Scotland, Edinburgh)

One of a group of paintings presented to Charles II by the States-General in celebration of the Restoration in 1660. Church interiors of this type appeal to modern viewers because of the abstract qualities evoked by the architecture.

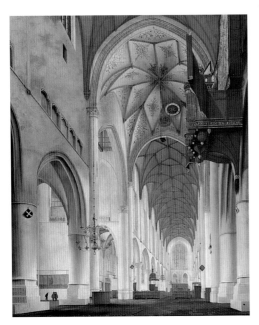

visitors. Sir Robert Kerr (later 1st Earl of Ancram; 1578–1654) visited the artist in his studio in Leiden in 1629 while on a diplomatic mission to Holland and returned with three works (two by Rembrandt) which he later presented to Charles I (1600–1649) – the first works by the artist to enter a British collection. Several Dutch artists actually came to work in London – Gerrit van Honthorst, Cornelis van Poelenburgh, Hendrick Pot and Gerrit Houckgeest worked for Charles I; and at the time of the Restoration in 1660 Charles II (1630–85) was given a group of paintings by the States-General. These were mostly Italian, but there were four Dutch examples including *Interior of St Bavo's Church, Haarlem* of 1648 (fig. 6) by Pieter Jansz. Saenredam (1597–1665) – now in the National Gallery of Scotland, Edinburgh – and *The Young Mother* by Gerrit Dou, which was

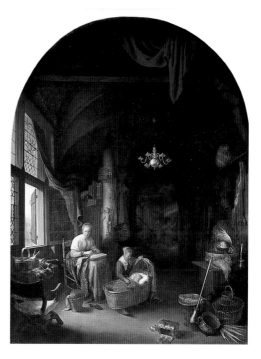

7. Gerrit Dou, *The Young Mother*, 1658
(Mauritshuis, The Hague)

This outstanding example of Dou's intricate style was given by the States-General to Charles II, but sent to the Palace of Het Loo at Apeldoorn by William III and never returned to the British court.

returned by William III to Holland, where it can be seen today in the Mauritshuis in The Hague (fig. 7). Dou's international reputation was in fact considerable, but he disliked leaving Leiden and so Charles II failed to lure him to London.

Other major collectors, such as Queen Christina of Sweden (1626–89), the Archduke Leopold Wilhelm (1614–62), and Cosimo III de' Medici, Grand Duke of Tuscany (1642–1723), eagerly sought Dou's work and were charged satisfactorily high prices for their pains on account of his slow, immaculate technique and enamel-like surfaces. Other artists from Leiden painting in the

same style were also in demand. Frans van Mieris the Elder received important commissions from Cosimo III, and Archduke Leopold Wilhelm attempted unsuccessfully to lure him to Vienna as court painter. Even more spectacular was the rise of Adriaen van der Werff from Rotterdam, who was appointed court painter to Johan Wilhelm, Elector Palatine (1658–1716), in Düsseldorf in 1697 on condition that he worked exclusively for him for six months of the year. This appointment was extended in 1703 to nine months following his knighthood. Other important collectors – Augustus, Elector of Saxony and King of Poland (1670–1733), and Duke Anton Ulrich of Brunswick-Wolfenbüttel (1633–1714) – visited van der Werff's studio in Rotterdam and the 1st Duke of Marlborough (1650–1722) had his portrait painted by him in 1704 following his victory at the Battle of Blenheim. Jan Baptist Weenix (1621–c.1663) worked for Cardinal Giovanni Battista Pamphili (later Innocent X; 1574–1655) when he was in Rome during the 1640s and his son Jan Weenix, like van der Werff, was appointed court painter (c.1702–14 or later) to the Elector Palatine in Düsseldorf. The still-life painter Maria van Oosterwyck is also reported to have worked for a distinguished clientele which included Louis XIV, King Augustus of Poland, the Holy Roman Emperor Leopold I (1640–1705), and William III and Mary II (r.1662–94) in England – which she may well have visited.

The most spectacular transfer of loyalty occurred with the removal of the Willem van de Veldes, *père et fils*, from Amsterdam to London. These able marine artists, who had worked assiduously for the Dutch authorities in providing visual records of naval engagements and the might of the Dutch navy, found that following the French invasion of 1672 the market for their pictures had begun to crumble. They sought an alternative outlet and found it in London, where they continued to paint marine pictures, including scenes from the third Anglo-Dutch war (1672–4), for Charles II and James II (1633–1701). They were given a studio in The Queen's House at Greenwich, where many of their pictures are shown today. Van de Velde the Younger (b.1633) died in Westminster in 1707 and was buried in St James's Church, Piccadilly.

The impact of Dutch seventeenth-century art was heightened by the

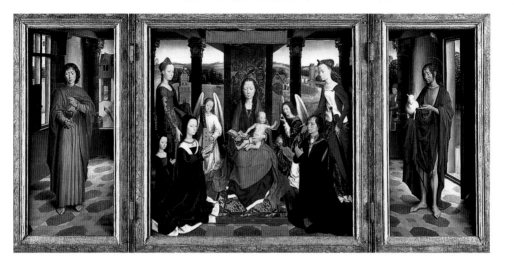

8. Hans Memlinc, 'The Donne Triptych', c.1475
(National Gallery, London, NG 6275.1)

The attention to detail in the rendering of all aspects of this famous early Netherlandish altarpiece in many respects anticipates Dutch paintings of the Golden Age.

innovations that were introduced into European painting by leading artists. It is as well to recognise, however, that the separation of the northern and southern provinces was in essence an artificial construct. Just as religious ties were not broken – it is surprising how many artists in the northern provinces were Catholic – so too cultural links were not totally fractured. A number of pictorial aspects developed by the Dutch in the seventeenth century can be seen in an incipient way in Flemish art of the fifteenth and sixteenth centuries. The crisp, immaculate folds of drapery and the acute awareness of texture; the spatial recession leading to backgrounds of urban views and gardens or across distant landscapes; the careful, exacting delineation of a variety of surfaces and still-life objects; the purposeful transcription of light: all these are features that can be found in early Netherlandish painting – in the work, for example, of Jan van Eyck (d.1441), Rogier van der Weyden (1399/1400–1464), Dieric Bouts (c.1415–75), Hans Memlinc (c.1430/40–94; fig. 8) or Petrus Christus

($c.1410–73$), albeit to the standards and within the possibilities of their own time. The same may be said of subject-matter in the sixteenth century. An artist such as Pieter Bruegel the Elder ($c.1525–69$) combined pure landscape with scenes from peasant life incorporating a whole range of rural activities that are echoed by later artists. These artists provide in essence the antecedents of Dutch seventeenth-century art – which in certain respects can be seen as an extrapolation of them but with a different and more pronounced emphasis on the secular. It is, in fact, these changes of emphasis that allowed Dutch art to reinforce its own characteristics, which are so recognisable today.

First of all, it was an art of landscape in the literal sense of artists recording their physical surroundings. The landscape in Holland was under permanent observation simply because of its geological peculiarities, particularly along the seaboard. Furthermore, the effects of sun, wind and water kept nature in a constant state of flux. The panoramic views of Philips Koninck (1619–88), with low horizons and the feel of moisture in the air, are particularly evocative in these respects. On the other hand, painters such as Jan van Goyen (1596–1656) and Jan Wynants sought to capture the transitory aspects of landscape that would be lost for ever – the shifting sand dunes and the coursing water are deftly recorded in a spirit of nostalgia. It was also a landscape that was being worked on or passed through – as in the paintings of Hobbema or, more significantly, those of Jacob van Ruisdael. Landscapes by Ruisdael often incorporate views of particular places, such as Haarlem, thereby providing a context that highlights the socio-economic interaction between town and country, although observers such as J.W. Goethe (1749–1832) and John Constable (1776–1837) found deeper meanings within them. Another strand of Dutch landscape painting was inspired by Italy. Artists like Berchem, Jan Both ($c.1610–52$), van Poelenburgh and Adam Pynackar (1620–73), who had experienced the warmth of Italy and seen the classical ruins in Rome or the Campagna to the south, were inspired to paint timeless Arcadian landscapes populated by shepherds and shepherdesses passing the time of day under a sun that never sets. The popularity of these glowing imaginary landscapes was such that those painters who had been to

Italy continued to paint in this way even after they had returned to the north. As it happened, this coincided with the extension of Dutch trade into the Mediterranean, which is why the Italianate harbour scenes painted by artists such as Jan Baptist Weenix sold so well. In addition to these artists, there were some who never left Holland, but who benefited from those who had made the journey to Italy. Chief amongst these was Cuyp, whose pictures had an undeniably seductive effect on British collectors on account of the treatment of the buttery golden light. William Hazlitt (1778–1830) described one of these pictures by Cuyp as being 'woven of etherial hues' and as having 'an effect like the down on an unripe nectarine'.

At the same time, Dutch painters were evolving the depiction of townscapes. Architectural painting is a Flemish tradition perfected by Dutch artists before being further developed in the eighteenth century by Antonio Canaletto (1697–1768) and, more particularly, by his nephew Bernardo Bellotto (c.1721–80). Works by Houckgeest retain the savour of the treatise, but specialists such as Gerrit Berckheyde (1638–98) and Jan van der Heyden in their views not just of Amsterdam and other cities, but also of smaller towns, temper the effects of structural clarity with vignettes of everyday life. These pictures show how, as in the countryside, people relate to their environment, only now it is in a context of groups of buildings as opposed to nature. Van der Heyden depicts the world in microcosm, recording small, passing incidents that are set against a more permanent fixed background – which is in fact very much how any urban society sees itself, even in the modern world. Emanuel de Witte (c.1617–91) and Saenredam extend the telescope and portray buildings – both exteriors and interiors – as if in close-up. Architectural painting is the basis of their art and there is a strong emphasis on perspective, but the compositions do have human interest even if the figures exist merely to express civic pride. Today works by de Witte and Saenredam appeal more because of their abstract qualities.

Genre painting was so successful in seventeenth-century Holland because mastery of technique matched treatment of subject-matter. The courtyards and

interiors seen in works by de Hooch and Vermeer are drawn according to surprisingly rigorous perspectival systems offset by opalescent light and carefully selected colours. What begins as geometry ends as poetry. In such paintings the viewer is witness to a whole range of intimacies that remain in the world of ambiguity: it is the uncertainty of the outcome that is arresting. At the fulcrum of Dutch seventeenth-century genre painting is the balance between the exterior and the interior, both physical and intellectual, and a great deal of its attraction lies in this duality.

The world of ter Borch, Gabriel Metsu, Caspar Netscher (c.1635–84) and Frans van Mieris the Elder is different from that of de Hooch and Vermeer, but it is no less potent. For them it is not so much the courtyard, the kitchen or the music room, as the parlour and the bedroom. Visits from the doctor, secret assignations, letters specially delivered by maids, the care of children, the cherishing of pets – these are the subjects broached in works by these painters, always in a more knowing way than Vermeer would countenance. Vermeer and de Hooch understate their themes or even deliberately avoid articulating them, but ter Borch, Metsu, Netscher and van Mieris have a firm commitment to an extended narrative.

Other painters pushed genre themes into yet further areas – Nicolaes Maes into the running of the domestic household; Steen into a rollicking world of inn, schoolroom and hallway; and Adriaen van Ostade into peasant cottages and the burlesque of rural taverns. Philips Wouwermans and Adriaen van de Velde depict the contrasting sides of rural life where people are in transit either out hunting, travelling from one destination to another, or trailing round the countryside as camp-followers: they stop at inns, attend local fairs or call in at booths. Where Wouwermans depicts a busy world with rococo delicacy, Adriaen van de Velde often lapses into classical repose. Military or guardroom subjects had an appeal, as did tavern scenes and merry-making groups. Commercial transactions were also given an outlet in painting. Dou in particular liked to draw attention to the quality of life in Holland by painting lavishly stocked shops, all laid out for the benefit of the viewer. The purpose was to admire not only the skill of the painter,

but also the wide range of produce either grown in Holland or imported into the country from far-flung places in the Empire.

This account by no means exhausts all the types of genre painting in Dutch seventeenth-century art and it should be recalled that nearly all the artists concerned also painted portraits and religious pictures in considerable numbers. Nonetheless, it is the capaciousness of Dutch art and the profligacy of subject-matter that created a captive audience.

There were, however, two further categories of Dutch painting that amount to singular contributions to European art. Firstly, there was still-life painting, which included flower pieces and food seen with a variety of utensils. Such pictures reflect pride in the commonplace elements of life. As far as flowers are concerned, there is a mixture of scientific curiosity with potential symbolism, whereas the so-called 'breakfast' and 'banqueting' still-life pieces combine the mundane with the exotic. Some of these paintings are directly linked to the *vanitas* theme reminding the viewer of the transitoriness of life, but others are an effulgent outpouring of appreciation for the beauty of the natural world. There is thus a haunting melancholy in a still life by Pieter Claesz. (*c*.1597–1660) or Willem Claesz. Heda and an overpowering sense of enrichment in still lifes by Jan van Huysum (1682–1749), Jan Davidsz. de Heem (1606–*c*.1683) or Willem Kalf (1622–93). At the beginning of the twentieth century Henri Matisse (1869–1954; fig. 9) painted a variation on de Heem's still life now in the Louvre, Paris, later stressing the formal qualities of such works: 'The emotion of the ensemble, the interrelation of the objects, the specific character of each object – unified by its relation to the others – all interlaced like a cord or a serpent. The tear-like quality of this slender, fat bellied vase – the generous volume of this copper – must touch you. A still life is as difficult as an antique and the proportions of the various parts as important as the proportions of the head or the hands, for instance, of the antique.'

Not unexpectedly, marine painting was another specialised area for artists. Again there is a remarkable progression from the beginnings made by Hendrick Cornelisz Vroom (*c*.1563–1640), Adam Willaerts and Jan Porcellis

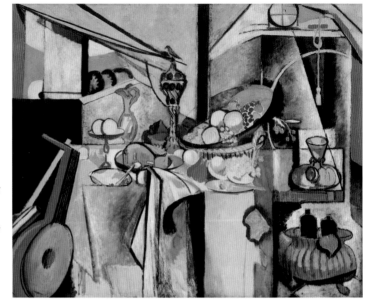

9. Henri Matisse,
*Still life after Jan
Davidsz. de Heem's
'La Desserte'*, 1915
(The Museum of Modern Art,
New York. Gift and Bequest
of Florene M. Schoenborn
and Samuel A. Marx)

Matisse paid close attention
to the work of Jan Davidsz.
de Heem and used the earlier
artist's still lifes as a reference
point at several critical stages
in his own career. In this copy
Matisse is experimenting with
Cubism.

(*c*.1580–1632) as their bird's-eye viewpoints gradually descend to sea level. Aerial perspective, howling wind, agitated water and darkening skies were as much the province of marine painters as calm open spaces, majestic forms and sagging sails. The sophistication introduced into this type of painting by artists such as Simon de Vlieger (*c*.1600–1653), and Jan van de Capelle (1626–79) comes to a climax with the work of Willem van de Velde the Younger, where the whole range of the skills required of a marine painter are on view. The rise and fall of the sea, the detailing of the vessels, the reflective qualities of water, the magnitude of the sky and the lure of distant horizons are due as much to the creation of atmosphere as to the formal elements. It is but a step from the perfectly judged verticals, horizontals and diagonals in a painting by Willem van de Velde the Younger to the works of Piet Mondrian (1872–1944; fig. 10). After Willem van de Velde had departed for London, his place in Holland was taken by Ludolf Bakhuisen (1631–1708), who specialised in scenes of rough

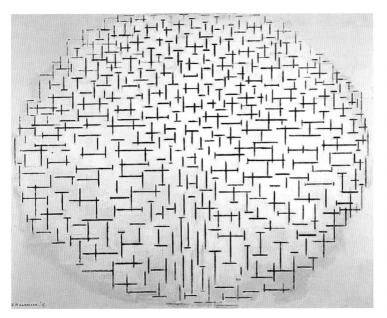

10. Piet Mondrian,
*Composition 10
(Pier and Ocean),
1915*
(Kröller-Müller Museum,
Otterlo)

Born in Holland,
Mondrian never lost
his fascination for the
sea and in a series of
increasingly abstract
paintings explored
the interrelationship
between water and a
projecting pier. These
two opposing forces
establish a rhythm that
enlivens the surface
of the canvas.

water and was patronised by Tsar Peter the Great (1672–1725). It was left to
J.M.W. Turner (1775–1851) to raise all these aspects of marine painting onto an
even higher level (fig. 11)

The establishment of the United Provinces and their impact on the political,
commercial and cultural scene soon attracted visitors. The traveller Peter Mundy
(1608–67) recorded early in the seventeenth century that people there had a
love of pictures: 'All in generall striving to adorne their houses, especially the
outer or street roome, with costly peeces, Butchers and bakers not much
inferiour in their shoppes, which are Fairely sett Forth, yea many tymes
blacksmithes, Cobblers, etts., will have some picture or other by their Forge and
in their stalle.' John Evelyn (1620–1706) made a similar observation while
travelling extensively in Holland as a young man. He wrote an entry in his *Diary*
for 13 August 1641 explaining that shortage of land had encouraged people to
invest in art:

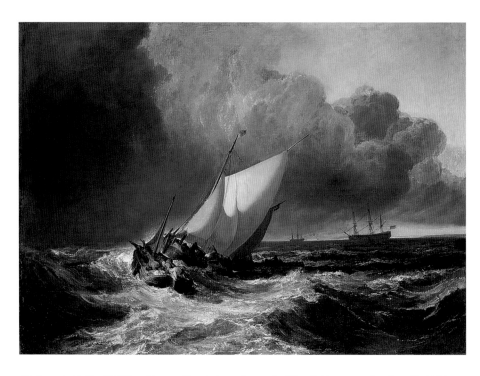

11. Joseph Mallord William Turner, *Dutch boats in a gale ('The Bridgewater Sea Piece')*, 1801
(Private Collection on loan to the National Gallery, London)

The painting was commissioned by the Duke of Bridgewater as a pendant to *A rising gale* by Willem van de Velde the Younger (now in the Toledo Museum of Art, Ohio). Turner greatly admired the Dutch marine artist, who came to London to work for Charles II and James II.

> We arrived late at Rotterdam, where was at that time their annual Mart or Faire, so furnish'd with pictures (especially Landscips, and Drolleries, as they call those clownish representations) as I was amaz'd: some of these I bought and sent into England. The reason of this store of pictures, and their cheapenesse proceede from their want of Land, to employ their Stock; so as 'tis an ordinary thing to find, a common Farmor lay out two, or 3000 pounds in this Commodity, their houses are full of them, and they vend them at their Kermas'es [fairs] to very great gaines.

And in Amsterdam he was spellbound, writing: 'Prodigious it is to consider those multitudes, and innumerable Assemblys of Shipps, & Vessels which continually ride before this Citty, which is certainly the most busie concourse of mortall men, now upon the face of the whole Earth & the most addicted to commerce.'

Amongst other early travellers to Holland, Samuel Pepys (1633–1703), as secretary to Edward Montagu, 1st Earl of Sandwich, sailed there in order to accompany Charles II back to London in 1660. He visited Delft and went sightseeing. The description in his *Diary* gives the impression of novelty and pristine neatness:

18 May. To Delfe to see the town, where when we were come, we got a smith's boy to go along with us (but could speak nothing but Dutch), and he showed us the church where Van Trump lies intombed with a very fine Monument: his epitaph concludes thus: *Tandem Bello Anglico tantum non victor certé invictus vivere et vincere desijt.* [At last though not victor yet certainly unconquered in the war with England, he gave up fighting and living.] There is a sea-fight the best cut in Marble, with the Smoake the best expressed that ever I saw in my life. From thence to the great church that stands in fine great Merket-place over against the Stathouse; and there I saw a stately tomb of the old Prince of Orange, of Marble and brass. Wherein, among other rarities, there is the angels with their trumpets, expressed as it were calling. Here were very fine organs in both the churches. It is a most sweet town, with bridges and a river in every street.

Pepys liked paintings, but he does not single them out as Evelyn did or as William Aglionby did later in his *The Present State of the Low Countries* (1669): 'Good pictures are very common here, there being scarce an ordinary tradesman whose house is not adorned with them.' Rich families on average had about fifty paintings in their houses.

By the eighteenth century, when the Golden Age had nearly passed, visitors to Holland and those with a more considered interest in Dutch art began to develop a more historical approach. Such a development was allied to theoretical writings on art, which during the seventeenth century in France and Italy extolled the virtues of the classical tradition, whereby artists sought the ideal by a process of selection from nature. The difficulty with the Dutch school, according to these theorists, was that artists were not selective enough and were in fact too indiscriminate and too literal in their attempt to imitate nature. Added to this was the choice of mundane subject-matter, which the viewer could not possibly find elevating or edifying. Influential writers such as Jonathan Richardson the Elder (1665–1745) at the start of the eighteenth century respected Dutch artists for their use of colour and for their accurate imitation of nature in genre subjects, but thought that altogether their works lacked the credentials of great art – invention in design and facility in execution. On any comparison with Raphael (1483–1520) the Dutch would always be found wanting.

The main theorist in Britain during the later eighteenth century was the first President of the Royal Academy, Sir Joshua Reynolds (1723–92). He first addressed the problems posed by Dutch art in his *Discourses* to the students of the Royal Academy. In Discourse IV (1771) Reynolds places the Roman, Florentine and Bolognese schools on the summit with the Venetian, Dutch and Flemish schools at a lower level – 'all professing to depart from the great purposes of painting, and catching at applause by inferior qualities'. But Reynolds also defines Dutch painting quite accurately and there is a tinge of regret in the fact that it has different standards:

With them, a history-piece is properly a portrait of themselves; whether they describe the inside or outside of their houses, we have their own people engaged in their own peculiar occupations; working or drinking, playing or fighting. The circumstances that enter into a picture of this kind, are so far from giving a general view of human life, that they

exhibit all the minute particularities of a nation differing in several respects from the rest of mankind. Yet, let them have their share of more humble praise. The painters of this school are excellent in their own way; they are only ridiculous when they attempt general history on their own narrow principles, and debase great events by the meanness of their characters.

A touchstone for Reynolds was the work of Jan Steen, whose efforts are assessed in Discourse VI (1774):

…Jan Steen seems to be one of the most diligent and accurate observers of what passed in those scenes which he frequented, and which were to him an academy. I can easily imagine, that if this extraordinary man had had the good fortune to have been born in Italy, instead of Holland, had he lived in Rome, instead of Leyden, and been blessed with Michael Angelo and Raffaelle, for his masters, instead of Brouwer and Van Goyen; the same sagacity and penetration which distinguished so accurately the different characters and expression in his vulgar figures, would, when exerted in the selection and imitation of what was great and elevated in nature, have been equally successful; and he now would have ranged with the great pillars and supporters of our Art.

Reynolds returns to this topic during the journey he made to The Netherlands and Belgium in the late summer of 1781. The notes he kept on that journey were published posthumously in his collected *Works* (1797) and entitled *A Journey to Flanders and Holland in the Year 1781*. He describes in considerable detail the paintings he saw in public and private collections, but did not alter his conclusions:

The account which has now been given of the Dutch pictures is, I confess, more barren of entertainment, than I expected. One would wish to be

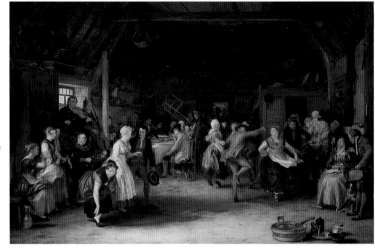

12. Sir David Wilkie,
The Penny Wedding,
1818
(RCIN 405536)

Early paintings by Wilkie
reveal the influence
of Dutch and Flemish
painters whose works were
abundantly represented
in British collections at
the beginning of the
nineteenth century.
Adriaen van Ostade was
a particular source of
inspiration.

able to convey to the reader some idea of that excellence, the sight of
which has afforded so much pleasure: but as their merit often consists in
the truth of representation alone, whatever praise they deserve, whatever
pleasure they give when under the eye, they make but a poor figure in
description. It is to the eye only that the works of this school are
addressed; it is not therefore to be wondered at, that what was intended
solely for the gratification of one sense, succeeds but ill, when applied
to another.

The final verdict in view of Reynolds's open-mindedness is fairly withering:
'Painters should go to the Dutch school to learn the art of painting, as they
would go to a grammar-school to learn languages. They must go to Italy to learn
the higher branches of knowledge.' In spite of such intellectual strictures,
various types of painting in Britain during the early nineteenth century owed a
great deal to Dutch seventeenth-century art. The early works of Sir David Wilkie
(1785–1841), for example, are steeped in the traditions of Dutch and Flemish
artists (fig. 12).

The fact that British artists were so aware of Dutch painting was due in great part to the number of important pictures by artists of that school in British collections in the nineteenth century. In this respect one of the foremost collectors was George IV (1762–1830). Indeed, the most expensive picture he ever bought was *'The Shipbuilder and his Wife'* by Rembrandt (fig. 5), which was acquired in 1811 at a cost of 5,000 guineas (£5,250). Following the upheavals of the French Revolution in 1789, the market for pictures in Europe expanded dramatically and in so far as George IV was an admirer of French eighteenth-century taste it is logical that by extension he too should appreciate the kind of Dutch painting that the great collectors of the recent past had admired. George IV, therefore, transformed the holdings of Dutch art in the Royal Collection, adding works of supreme quality by artists such as Rembrandt, Steen, de Hooch, Cuyp, Adriaen van Ostade, Jacob van Ruisdael, Adriaen van de Velde and Wouwermans. Many of these additions were made in a frenzied bout of collecting in 1811, but the climax was reached in 1814 with the purchase of eighty-six paintings from the collection formed by the banker Sir Francis Baring (1740–1810) and his son Sir Thomas Baring (1772–1848). This was a truly representative collection of Dutch seventeenth-century painting and the acquisition increased the number of Dutch pictures owned by George IV to about two hundred. He particularly appreciated genre painting, landscapes and portraits, but seems to have had little consideration for still lifes. His taste was essentially conservative and was shared by several other collectors of the time, particularly the 3rd Marquess of Hertford (1777–1842), whose Dutch pictures can be seen at the Wallace Collection in London. For such collectors subject-matter, technical proficiency and a high degree of finish were the determining elements in their admiration for Dutch art. British artists could gain knowledge of the pictures in these collections through personal acquaintance, or prints, or loans to exhibitions – which were becoming more frequent through organisations such as the British Institution. *The Passage Boat* by Cuyp is a picture that may well have influenced Augustus Callcott (1779–1844) and J.M.W. Turner.

The modern appreciation of Dutch seventeenth-century painting has its origins in nineteenth-century France. The illustrated compendium *Histoire des Peintres de Toutes les Ecoles*, edited by Charles Blanc (1813–82) and published in fourteen volumes between 1853 and 1875, introduced a number of Dutch painters and their works to French readers through the comparatively cheap form of reproduction by wood engraving. The *Histoire*'s two volumes on Dutch art appeared in 1861. This publication included the first article ever devoted entirely to the career of Vermeer, but beyond that Blanc's publication became a source for French painters; it is known that Edouard Manet (1832–83) for one consulted it. Blanc was a literary figure, the first editor of the journal *Gazette des Beaux-Arts* and later a literary member of the Académie des Beaux-Arts and Académie Française on account of his publications, but his *Histoire* was surpassed by the appearance in 1876 of a travel book, *Les Maîtres d'autrefois* by the painter Eugène Fromentin (1820–76). As an artist Fromentin gained a moderate reputation for his scenes of life in North Africa where he travelled during the 1840s and 1850s. His work falls into the category of 'orientalism' as pursued by Eugène Delacroix (1798–1863), Alexandre-Gabriel Decamps (1803–60) and Théodore Chassériau (1819–56), but his greatest claim to fame is the account of his journey to Belgium and Holland in July 1875. The section on Dutch painting is based on first-hand knowledge of both the country and its art. He combines a general account of the school with studies of individual artists and pictures. As an interpretation of Dutch art what Fromentin wrote in *Les Maîtres d'autrefois* proved to be influential. He declares the object of Dutch painting to have been 'to paint its own portrait', and he continues: 'This word says everything. Dutch painting, as one very soon perceives, was not and could not be anything but the portrait of Holland, its external image, faithful, exact, complete, life-like, without any adornment. The portrait of men and places, of *bourgeois* customs, of squares, streets, and countryside, of sea and sky – such was bound to be, reduced to its primary elements, the programme adopted by the Dutch School; and such it was, from its first day until its decline.'

There follow some elegiac descriptions – experienced in life as well as in art

– of the subjects undertaken by seventeenth-century artists, but, it is argued, within their art a moral purpose can be deduced:

The object is to imitate that which is, to make what is imitated loved, to express clearly one's simple, strong, deep feelings. The style, then, will have the simplicity and clarity of the principle. Its law is to be sincere, its obligation to be truthful. Its first condition is to be familiar, natural, expressive; it follows from a concourse of moral qualities – *naïveté*, patient goodwill, and uprightness. We might almost call them domestic virtues, taken from private life and used in the practice of art, which serve equally to guide one aright and to enable one to paint well. If you take away from Dutch art that which might be called probity, you will no longer understand its vital element; and it will no longer be possible to define either its morality or its style. But just as there are in the most practical of lives motives and influences that ennoble the behaviour, so in this art, held to be so positive, among these painters, held for the most part to be mere copiers of detail, we feel a loftiness and a goodness of heart, an affection for the true, a love for the real, that give their works a value the things do not seem to possess.

Fromentin also describes the basic characteristics of a Dutch painting:

It is of small format, of powerful and sober colour, of concentrated effect… It is a painting that has been diligently worked at, in an orderly manner, which denotes a steady hand, the artist seated at his work, which requires perfect self-possession and inspires it in those who study it. Mind has meditated to conceive it, mind meditates to understand it… No painting gives a clearer idea of this triple and silent operation – feeling, reflecting, expressing. Neither is any painting more condensed, for none encloses in so small a space so many things or is forced to say so much in so small a setting. And thus everything assumes a conciser,

preciser form, a greater density. The colouring is stronger, the drawing more intimate, the effect more central, the interest more circumscribed… No painting leads with greater certainty from the foreground to the background, from the border to the horizons. We live in the picture, we walk about in it, we look into its depths, we are tempted to raise our heads to look at its sky. Everything unites to produce this illusion…

The importance of Fromentin is that he recognises to what extent choice of subject-matter and style serve artistic purpose. A puzzling feature of Fromentin's book – at least from a modern viewpoint – is that the author showed only a passing interest in Vermeer. The reason for this is that it was only in 1866 that the art critic and political activist Théophile Thoré (whose pseudonym was William Bürger; 1807–69) published the first serious study on the artist whose *View of Delft* (1658–60) he had first seen in Holland in 1842. Thoré set about finding other works by Vermeer and compiling a critical catalogue of them – one of the first of its kind. Other writers had become aware of Vermeer's paintings, but Thoré was the first to combine enthusiasm and research with a sense of purpose. His publication on Vermeer had serious faults and shortcomings, but Thoré's achievement was, nonetheless, 'one of the great epics of art-historical research and imagination'.

Meanwhile, in Britain there was no such defence of Dutch painting as Fromentin's and no such pioneering work as Thoré's. What debate there was revolved around the subject-matter. The artist William Collins (1788–1847), father of the novelist Wilkie Collins, for instance, opined in 1817 that 'Most of the Dutch pictures are composed of subjects gross, vulgar, and filthy; and where this is not the case with the subjects, the characters introduced are such as to degrade the human species below the level of brute creation…yet they are most profoundly skilled in the great technical beauties and difficulties of the Art…'. The novelist George Eliot (1819–80), however, chose to see only the moral dimension which she described so beautifully in *Adam Bede* (1859):

It is for this rare, precious quality of truthfulness that I delight in many Dutch paintings, which lofty-minded people despise. I find a source of delicious sympathy in these faithful pictures of a monotonous homely existence, which has been the fate of so many more among my fellow mortals than a life of absolute indigence, of tragic suffering or of world-stirring actions. I turn, without shrinking, from cloud-borne angels, from prophets, sibyls, and heroic warriors, to an old woman bending over her flower-pot, or eating her solitary dinner, while the noon-day light, softened perhaps by a screen of leaves, falls on her mob-cap, and just touches the rim of her spinning wheel, and her stone jug, and all those cheap common things which are the precious necessities of life to her.

The recent upsurge of interest in Dutch seventeenth-century painting presents a paradox. On the one hand, scholars have concentrated on seeing the art in its context, emphasising the need to understand that these paintings were made at a particular time and within a certain cultural milieu. The contribution of Dutch scholars such as Professor Eddy de Jongh drew attention to the range of possible symbolic meanings (sometimes hidden) and moral conclusions (not always direct) in pictures supported by reference to contemporary literature, especially poems and emblem books, many of them illustrated. For this approach the names and books of Johan de Brune (1588–1658), Jacob Cats (1577–1666) and Roemer Visscher (1586/7?–1652?) amongst others have become invaluable sources. It also needs to be borne in mind that many of the paintings of Hieronymus Bosch (c.1450–1516) and Pieter Bruegel the Elder in the sixteenth century either illustrated proverbs or can be linked with them. Another scholar, Svetlana Alpers, in her book *The Art of Describing. Dutch Art in the Seventeenth Century* (1983), set out not to write 'the *history* of Dutch art, but the Dutch *visual culture*' and so makes links with contemporary advances in knowledge. She writes, 'The aim of Dutch painters was to capture on a surface a great range of knowledge and information about the world' as scientists, explorers and philosophers were also doing. 'No single view dominates in the

interest of this additive way of piecing together the world. There is in Dutch painting a pleasure taken in description that is akin to what we find in the world of maps.' Dutch art is therefore both investigative and descriptive.

The historian Simon Schama in *The Embarrassment of Riches. An Interpretation of Dutch Culture in the Golden Age* (1987) uses a wide range of images to trace the priorities and concerns of a newly born society. At its centre there was a moral dilemma resulting from the birth of a nation whose very existence could be threatened by its own success. Paintings and other supporting images not only celebrate the values of that society, but also reveal tensions. These are best observed in ordinary, everyday scenes of family life or at times of social transaction, whether that takes place at an inn, a shop or a brothel. For Schama Dutch art was an aspect of 'moral geography'. The importance of Dutch art for the historian (political, social or economic) is that Dutch artists were primarily concerned with the present and the existence of so many thousands of their pictures denotes a certain degree of compulsion. At the same time, it has to be recognised that since so much of the subject-matter of Dutch art was produced *ex-novo* the basic traditional terms of reference for interpretation are lacking: thus, the numerous 'readings' of these pictures. These two books by Alpers and Schama are only the tip of the iceberg. Others have been published since the 1980s – for example, Martha Hollander, *An Entrance for the Eyes. Space and Meaning in Seventeenth-century Dutch Art* (2002) and Rodney Nevitt, *Art and the Culture of Love in Seventeenth-century Holland* (2002); yet more titles will no doubt follow.

The attempts by scholars to seek out meanings (hidden or otherwise) in Dutch art encourage the viewer to look into paintings. A second recent development is in the field of literature, where the viewer is invited to step into the picture. Novelists have been so inspired by certain pictures, or by themes associated with Dutch art, that they have re-created imaginary situations based on the people seen in pictures by Vermeer, de Hooch or Maes. The bookshop of the National Gallery in London has a section called Art Fiction which includes titles such as *Tulip Fever* by Deborah Moggach (1999), *Girl with a Pearl Earring* by

Tracy Chevalier (1999) and *Girl in Hyacinth Blue* by Susan Vreeland (1999). The novel – more than the cinema (*Girl with a Pearl Earring*, 2004) – is perhaps the art form most closely allied to Dutch genre painting, but it also demonstrates the duality that exists in the pictures. This characteristic stems from the accessibility of the subject-matter and from its enigmatic presentation: thus the everyday becomes imbued with deeper, more lasting values. As has been seen, this was a dichotomy that exercised art theorists in the eighteenth century – but it also inspired Marcel Proust (1871–1922), whose favourite artist was Vermeer. Today seventeenth-century Dutch art is appreciated for its associational qualities: it is an art very much rooted in its own time, yet its engagement with issues that are pertinent to the modern world means that it transcends the boundaries of the Golden Age.

Note: At the end of the entries that follow, references to White are to C. White, *The Dutch Pictures in the Collection of Her Majesty The Queen*, Cambridge, 1982.

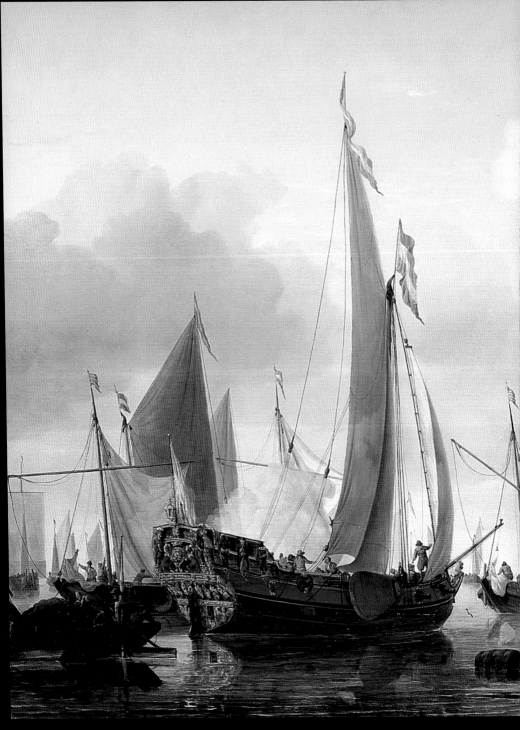

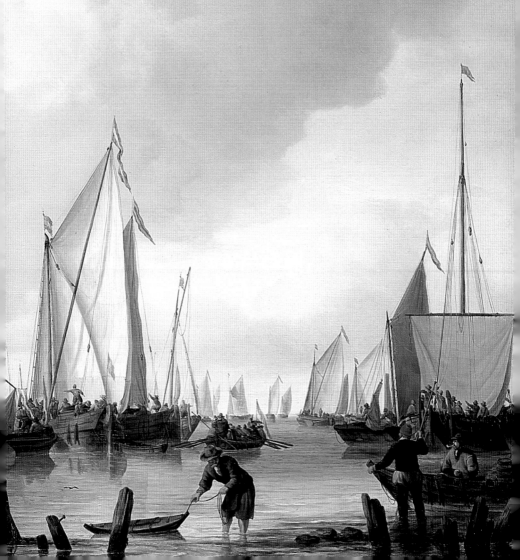

ENCHANTING THE EYE

NICOLAES BERCHEM

(1620–1683)

Italian landscape with figures and animals: a village on a mountain plateau

Oil on panel
33.0 × 44.1 cm (13 × 17⅜")
Signed and dated lower left: *Berghem/1655*
RCIN 404818

Berchem, the son of the still-life painter Pieter Claesz., was one of the most prolific and popular artists of the Dutch seventeenth century. His oeuvre of some eight hundred works ranges over biblical, mythological and allegorical subjects, but is dominated by several different types of landscape painting. In addition, he made numerous drawings and prints. His output was further extended by collaboration with artists such as Jacob van Ruisdael.

Berchem spent the first part of his life in Haarlem, where he was born, but he lived permanently in Amsterdam from 1677. A great deal of his work reveals the influence, in terms of both style and subject-matter, of those Netherlandish artists who had travelled in Italy during the 1630s and 1640s. Although there is no documentary evidence, it is frequently claimed that Berchem was himself in Italy from 1653 to 1656.

Fame brought the artist a number of influential pupils, including Pieter de Hooch (page 81), Jacob Ochtervelt and Karel du Jardin, although only the last named strictly adhered to Berchem's example. Such was his popularity that even during the seventeenth century prints were being made after his compositions; this continued in the following century, by which time his paintings were eagerly sought after by leading European collectors.

Italian landscape certainly suggests knowledge of Italy (specifically perhaps of the Campagna south of Rome), but it does not necessarily prove the artist's presence on the peninsula. Indeed, the motif of the figure on horseback pointing towards buildings across the river can be found in *River landscape with shepherds* by Jan Asselyn (c.1615–52) in Vienna (Akademie für bildenden Künste).

Nonetheless, *Italian landscape* successfully evokes the much admired Arcadian atmosphere of the Campagna in the treatment of the decaying buildings and the golden light. The tonal values emphasise the changing aspects of the landscape and the suppleness of the brushwork creates a shimmering effect that draws the eye towards the distant mountains set against an azure sky.

The painting is recorded in Dutch collections at the end of the eighteenth century and was acquired by George IV with Sir Francis Baring's collection.

White, no. 20

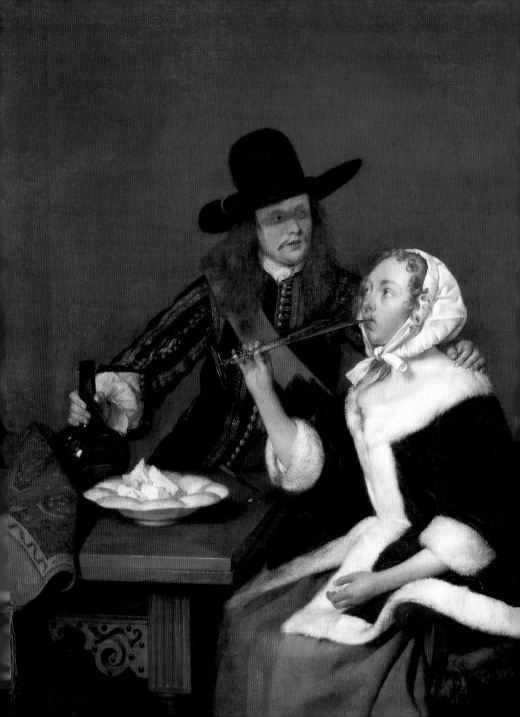

GERARD TER BORCH

(1617–1681)

A gentleman pressing
a lady to drink

Oil on canvas
41.6 × 31.9 cm (16⅜ × 12⁹⁄₁₆″)
RCIN 404805

Ter Borch was born at Zwolle in the province of Overijssel bordering Germany. His father was a draughtsman who no doubt taught his son before apprenticing him in 1634 to Pieter Molijn (1595–1661) in Haarlem, where he entered the Guild of St Luke a year later. During the 1630s and 1640s ter Borch reportedly travelled extensively in England, France, Spain, Germany and Italy. During the rest of his life, even when in Holland, he was fairly peripatetic, although in 1654 he married and made Deventer, also in the province of Overijssel, the centre of his activities. As a painter ter Borch had a considerable range, beginning with guardroom scenes in the manner of Pieter Codde (1599–1678) and Willem Duyster (1599–1635), both of whom worked in Amsterdam, but towards the end of the 1650s he evolved his own style of small-scale portraiture and refined genre scenes on which his reputation today is based. In 1648 ter Borch also painted a single, but most significant, history picture, namely *The Swearing of the Oath of Ratification of the Treaty of Münster, 15 May 1648* (National Gallery, London), when Spain formally acknowledged the independence of the United Provinces of The Netherlands.

A gentleman pressing a lady to drink is a characteristic example of a genre scene by ter Borch (*c*.1660), although in this instance the compositional possibilities – found for example in *The Letter* (Royal Collection; fig. 2) – are more circumscribed by the simplicity of the setting. The painting was acquired by George IV in 1812. It was in France during the mid-eighteenth century; the French had a particular penchant for this type of Dutch painting. In the interaction of the two figures and the attention to detail ter Borch still manages, as so often in his work, to engage the viewer's attention to an unusual degree.

The painting has an implied narrative of seduction, the outcome of which is left to the imagination. A shadow falls across the man's face; his left hand is placed on the young woman's shoulder while with the other he holds on to the neck of the bottle of wine. It is a striking, almost sinister pose, countered by that of the young woman, whose compliance is registered by the raising of the tulip glass to her lips while gazing into the man's eyes. The model for the female figure is an idealised type often said to be based on the artist's gifted step-sister, Gesina ter Borch, who appears in many of these genre paintings. The care lavished on the fur-trimmed garment, the cap and the curls of hair epitomises ter Borch's meticulous degree of finish, just as the psychological overtones inherent in the scene explain the artist's appeal to modern viewers. The plate of cheese on the table may have an iconographical significance, but is as yet unexplained.

The subject of a figure drinking, or being encouraged to drink, is not unusual in ter Borch's oeuvre. It can also be found in Vermeer – *The glass of wine*, *c*.1658–60 (Gemäldegalerie, Berlin), and *The girl with the wineglass*, *c*.1659–60 (Herzog Anton Ulrich Museum, Brunswick), both compositions conceived on a different level of technical sophistication. It is known that ter Borch had met Vermeer in Delft in 1653.

White, no. 28

JAN DE BRAY

(c.1627–1697)

The Banquet of Cleopatra

Oil on canvas
170.7 × 165.8 cm (67 ⁷⁄₁₆ × 65 ¼")
Signed and dated on the tablecloth: *JDBray*
(*JDB* in monogram) / *1652*
[centred beneath signature]: *56* [or *8*]
RCIN 404756

The story of the banquet of Cleopatra is recounted in the *Natural History* of Pliny (Book IX, lines 119–21), which was translated into Dutch in 1660. A more popular, alternative source for the story was Jacob Cats's description of the banquet in *Huwelijk van Antonius en Cleopatra*, incorporated into his long poem *Trouringh* (Dordrecht, 1637). Pliny related that two of the largest pearls in the world were owned by Cleopatra, Queen of Egypt. She scoffs at her lover, the Roman Mark Antony, and makes a bet with him that she is prepared to spend a fortune on a single feast. Although the meal appears at first to be frugal, Cleopatra wins the bet by removing one of her pearls from her ear and dissolving it in her wine, which she then drinks. The story was often painted by artists, notably by the Venetian artist Giambattista Tiepolo (1696–1770) in 1743–4 (National Gallery of Victoria, Melbourne), but not always from a moralising point of view, although in seventeenth-century Holland it would have been difficult to escape the imputation of vanity in such a scene.

Jan de Bray was the son of the painter, architect and poet Salomon de Bray (1597–1664) who lived in Haarlem and had at least ten children, of whom Jan was the eldest. Several members of the family died in the plague of 1663–4. As an artist Jan was as versatile as his father, specialising in portraits (some revealing the influence of Frans Hals – see page 68), although he did paint a few religious, mythological and genre subjects. He also made some prints and practised as an architect.

The Banquet of Cleopatra, which was probably acquired by Charles II, reveals de Bray's skills as a portraitist albeit in a narrative, historical context.

This painting is, in essence, a rather unusual family portrait. Not all the figures can be identified, but the principal ones seated at the table are the artist's parents: Salomon de Bray as Antony and his wife, Anna Westerbaen, as Cleopatra. The artist himself is at the left edge of the composition holding a halberd. Next to him at the front are two of the younger children – Jacob and one of his sisters – holding a pestle and mortar. Balancing them in the foreground on the right side are perhaps two of the children who died young. To the right of them is Josephas, holding a pewter dish, with another sister behind carrying two rummers on a silver dish. Behind her is another brother, Dirck. Armed attendants and a servant are visible in the background to left and right. The range of utensils made of different materials, and some of oriental origin, attests the geographical reach of the Dutch maritime empire. Aspects of the composition partake of the tradition of still-life painting. It is to de Bray's credit, therefore, that he reveals his ability to paint not only vivid portraits with a pronounced use of chiaroscuro, but also the textural and reflective qualities of inanimate objects. A possible reason for the double-dating of this painting (1652 and 1656 or 8) is that de Bray worked on the composition over a long period or retained it to make alterations. In 1669 the artist painted another version of the subject with some substantial changes; it is now in the Currier Museum of Art, New Hampshire. This is larger, with the composition considerably extended at the lower edge: the still life on the table is different and the

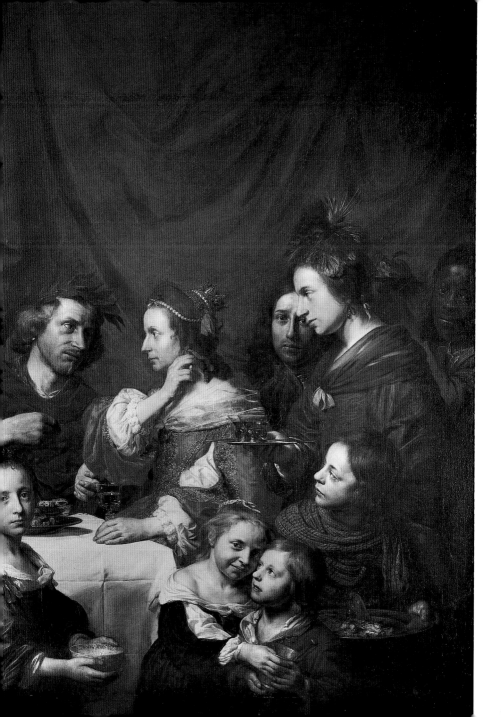

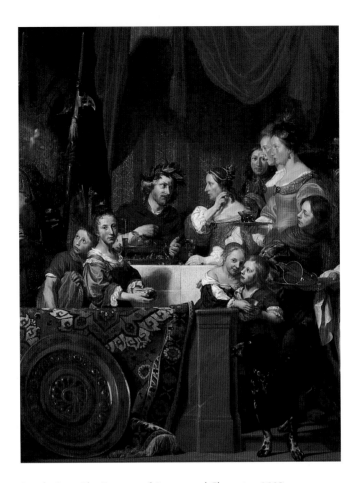

Jan de Bray, *The Banquet of Antony and Cleopatra*, 1669
(Currier Museum of Art, New Hampshire)

figures in the background on the left have been replaced by a peacock. The emphasis in the present picture is more on the portraits, which suggests that the artist perhaps intended the second version to be a memorial picture.

White, no. 31

HENDRICK TER BRUGGEN

(1588–1629)

A laughing bravo with a bass viol and a glass

Oil on canvas
104.6 × 85.2 cm (41⅟₁₆ × 33⅗₁₆″)
Signed and dated upper left:
HT Bruggen fecit 1625
RCIN 405531

Hendrick ter Bruggen was one of a group of painters from the Utrecht school profoundly influenced by seeing the work of Caravaggio in Rome. Known as the Utrecht Caravaggisti, ter Bruggen, with Dirck van Baburen (*c*.1595–1624) and Gerrit van Honthorst, painted in a pronouncedly Baroque style that suited a predominantly Catholic city. Ter Bruggen's work has won many recent admirers, particularly such moving compositions as *St Sebastian attended by Irene* (1625; Allen Memorial Art Museum, Oberlin College, Ohio).

Apart from religious compositions, ter Bruggen also painted a number of canvases of musicians to be shown either in pairs or singly. The figures in these paintings are not dressed in contemporary clothes, but almost certainly in theatrical, or occasionally pastoral, costume. *A laughing bravo* was acquired by Charles I. At the time of the Restoration in 1660 it was in the possession of the painter Sir Peter Lely (1618–80), who returned it to the crown. The origin of these compositions again lies in Caravaggio (for example, *The lute player* of 1595, The Hermitage, St Petersburg), who, however, treated the subject, and other related single-figure compositions, as exercises in genre. Ter Bruggen dispenses with any narrative or anecdotal interest and consequently his pictures are closer to allegories, even though he would have seen itinerant musicians of this kind on his return to Holland. If allegory is the intention in the present painting, then it could be interpreted as illustrating two of the five senses – Taste and Hearing. Some of the musicians depicted by ter Bruggen are introspective, but here the mood is more outgoing, emphasised by the scale of the figure seen from below. The artist used the same model in several other paintings.

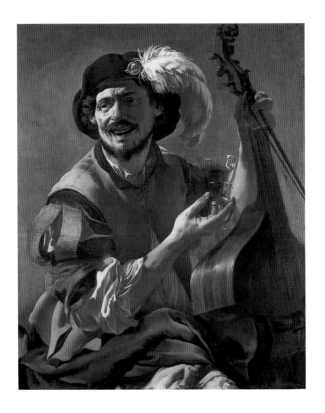

Ter Bruggen was apprenticed to Abraham Bloemaert (1564–1651). The exact dates of his years in Italy are not known and neither can it be established how long he was in Rome specifically, where he met Peter Paul Rubens (1577–1640). Usually his absence from Holland is said to be *c*.1607–14. He was one of the first artists from Utrecht to return to the north. Little is known about the painter's activities thereafter apart from his marriage, but his work was highly regarded during his lifetime and his pictures fetched high prices. An early biographer (Joachim van Sandrart), who knew him personally, records that ter Bruggen was a man of 'profound but melancholy thoughts'. He died of the plague.

White, no. 33

AELBERT CUYP

(1620–1691)

Evening landscape

Oil on canvas
101.6 × 153.6 cm (40 × 60⅟₁₆″)
Signed lower right: *A cuÿp*
RCIN 405827

The artist was born in Dordrecht, which remained the centre of his activities throughout his life. He was the son of a painter (Jan Gerritsz. Cuyp, 1594–1651/2), from whom he is likely to have received his initial training. Early on he specialised in landscape paintings, being influenced in this choice by the work of Jan van Goyen, Herman Saftleven (1609–85) and Salomon van Ruysdael (page 144). Early works by Cuyp follow in the tradition of the realistic depiction of landscape in so far as it recorded economic and social aspects of contemporary life, but from the mid-1640s after visiting Utrecht he came under the marked influence of those Dutch painters who had visited Italy – Berchem, Poelenburgh (page 124), and above all Jan Both. From this moment Cuyp began to paint idealised, classicising, pastoral landscapes that not only appealed to his patrons in Dordrecht, but also established him as one of the foremost landscape painters in the history of Dutch art. By the late eighteenth century Cuyp's pictures were much sought after by European, principally British, collectors and a startling consequence of this is that relatively few paintings by the artist can be seen in Holland today.

Cuyp never travelled to Italy himself, but in *c*.1652 he made a journey following the course of the river Rhine as far as Nijmegen and Cleve. He made numerous drawings of topographical motifs that he incorporated into later paintings. The background of *Evening landscape* is based on one such drawing, but the prominent part played by the tall trees on the right in the articulation of the spatial divisions of the composition is an effect derived from Both. The same background of mountains, castle ruins and distant town occurs with alterations in Cuyp's *River landscape with two horsemen* in Amsterdam (Rijksmuseum).

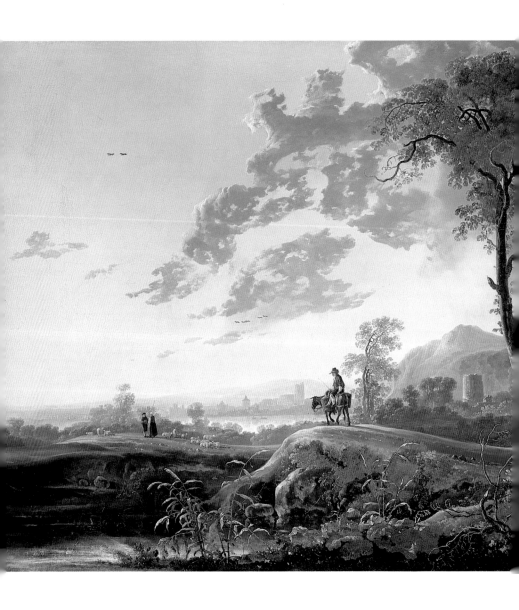

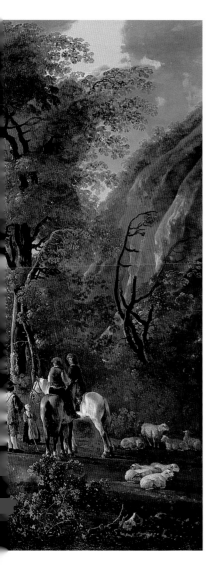

Evening landscape dates from the later 1650s and, like *River landscape with horseman and peasants* in the National Gallery, London, may well be one of Cuyp's last paintings. It possesses all the features that have made the artist so popular. Compositional effects can be readily acknowledged: the elaborate foreground which at first restrains the viewer, and the shallow diagonal in the middle distance setting the figures as though on a stage as they make their leisurely way through the landscape. Yet these are secondary to the overwhelming sense of calm stemming from the evening light that embalms the whole scene in various hues of buttery yellow pigment. The tonal gradations are extraordinarily deft not only in depicting spatial recession, but also in creating a sempiternal golden aura.

George IV acquired no fewer than seven works by Cuyp, of which *Evening landscape*, *The Passage Boat* and *The Negro Page* are outstanding. *Evening landscape* was previously in two famous Dutch collections – J. van der Linden van Slingeland (sold 1780) and Jan Gildemeester (sold 1800) – before entering the collection of Sir Francis Baring, which was purchased by George IV.

White, no. 35

AELBERT CUYP

(1620–1691)

Two cavalry troopers
talking to a peasant

Oil on panel
36.5 × 46.9 cm (14⅜ × 18⁷⁄₁₆")
RCIN 404801

A recurring theme in Cuyp's mature work is mounted figures in the landscape, often in conversation with passers-by. In many respects the social distinctions suggested by such subjects are relevant to the artist's own circumstances; after inheriting his father's patrons, he himself made in 1658 a propitious marriage to Cornelia Boschman, the widow of a wealthy regent and the granddaughter of the Calvinist theologian Franciscus Gomarus (1563–1641). Such a marriage gave Cuyp financial and social security and he subsequently became a deacon and elder of the Reformed Church in Dordrecht, a regent of a major charity associated with the Grote Kerk, and a member of the tribunal of South Holland. At his death he was one of the wealthiest citizens in Dordrecht. It is possible that his output as a painter declined after his marriage, although he continued to have pupils. More significant as regards the appreciation of his pictures is that in his choice of equestrian subject-matter Cuyp was painting to please his social equals – or, as Simon Schama has expressed it, the paintings of the 1650s show the artist 'dissolving into the cultural landscape of his own invention'.

Equitation was of great social significance in seventeenth-century Holland. It was an aspect of life that percolated through several layers of society and was a principal means of separating one class from another. Cuyp was fascinated by the art of horsemanship and its sartorial niceties, as well as by the specially bred horses (with small heads) and carefully trained sleek hunting dogs. The success of his late landscapes comes from the melding of these figures and animals into a suitably Arcadian setting. His patrons readily identified with such settings, and later land-owning collectors towards the end of the eighteenth century in Britain equally wanted to be associated with them in so far as they reflected their own aspirations.

Two cavalry troopers, which was acquired by George IV from the collection of Sir Francis Baring, dates from sometime in the 1650s. It is closely related in subject and in part compositionally to other works of the same decade by Cuyp. He often reused motifs in several pictures. For example, the dappled horse is similarly posed in *The Negro Page* of *c*.1650, a painting in the Royal Collection that is on a much larger scale. Similarly, he dressed his horsemen in a variety of clothes that combine utility with a poignant sense of the history of dress. It has been shown that the three-quarters-length flared coat, often decorated with braid, as worn by the standing trooper in this painting, is of Hungarian origin – a telling point of reference since the Hungarians were by tradition the finest horsemen in Europe both in battle and in the hunting field. The trooper who has remained on horseback is more fancifully dressed in a coat with slashed sleeves and a bonnet sporting a feather. These two figures are in fact so idiosyncratically clothed that it is not clear how technically they can be described as troopers, although that is the traditional title.

White, no. 36

GERRIT DOU

(1613–1675)

A girl chopping onions

Oil on panel
18.0 × 14.8 cm (7 $\frac{1}{16}$ × 5 $\frac{13}{16}$")
Signed and dated on side of mantelpiece
upper left: *GDOV* (*GD* in monogram) *1646*
RCIN 406358

Dou holds a place of the greatest importance in Dutch seventeenth-century painting as the founder of the school of the so-called *fijnschilders* in Leiden. As the term denotes, the style used by Dou and his numerous followers involved meticulous brushwork, close observation of objects, and a high degree of finish to the extent that the surfaces of their pictures look almost as if they have been polished. Dou's paintings are usually of small dimensions, but often crowded with items, sometimes to the point of clutter. A clue to Dou's success in this detailed type of painting is found in the fact that initially he was to have followed in his father's footsteps as a glass engraver. Subsequently, he pursued glass painting and engraving until in 1628 he entered Rembrandt's studio and trained as a painter in oils. After Rembrandt (pages 133–43) left for Amsterdam in 1631, Dou was free to develop his own painstaking style of painting that was in many respects very different from his master's, although he did in fact paint a wide range of subject-matter. Dou became a founding member of the Guild of St Luke in Leiden in 1648 and hardly ever left the city, even though he had established an international reputation for himself during his lifetime. He never married. He left a number of revealing self-portraits, and his style of painting remained influential into the eighteenth century.

A girl chopping onions is on a minute scale and is a perfect demonstration of the art of *fijnschilders* painting. The activities of kitchenmaids was one of Dou's favourite themes, in which he could not only indulge in brilliant passages of still-life painting, but also pursue artistic themes. Lascivious kitchenmaids were frequently the subject of comedic literature in seventeenth-century Holland, and painters emphasised their charms by the use of symbolism based on

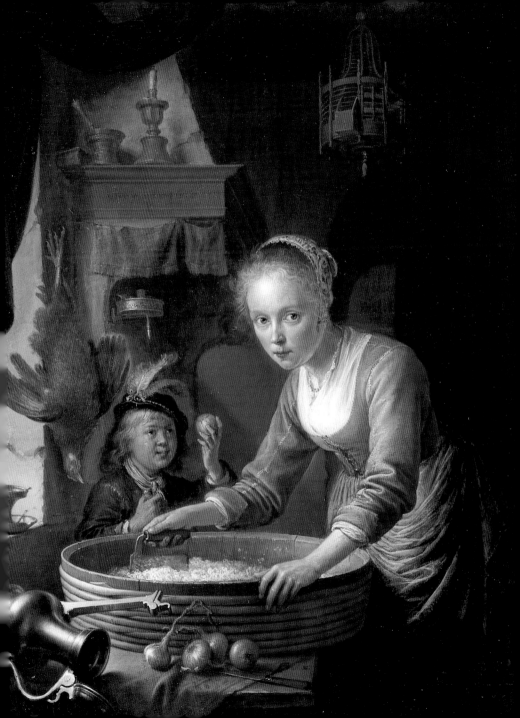

LE HACHIS D'OIGNONS
Du Cabinet de M. le Duc de Choiseul

Gerrit Dou, *A girl chopping onions*
engraving from *Recueil d'estampes gravées
d'après les tableaux du cabinet de
Monseigneur le Duc de Choiseul*, 1771

contemporary emblem books or proverbs. Thus, the empty bird-cage may be an allusion to loss of virtue and the dead fowl is a *double entendre* – the Dutch word *vogel* (bird) was also a slang term for 'copulation'. Many of the utensils in the picture – such as the candle, pestle and mortar, and the jug – have clear sexual connotations. In addition, the kitchenmaid looks straight out at the viewer whilst suggestively engaged in chopping onions, which in the seventeenth century were used as an aphrodisiac. All these disparate aspects, however, might be united in a wider meaning personified by the two figures: the small boy standing for innocence and the girl for experience. Yet this was not how it was interpreted when the picture was in France during the eighteenth century. When engraved by Pierre Louis Surugue (1716–72) the following caption was supplied as imaginary dialogue between the small boy (perhaps seen as Cupid) and the young woman: 'I am perfectly willing to believe that you are knowledgeable in the delectable art of preparing stews / But I feel even more appetite for you / Than for the stew that you are preparing.'

The motif of chopping onions first occurred in *The Kitchen* of c.1645 (Staatens Museum, Copenhagen) in which the same small boy also appears. The view into the kitchen is here made possible by the raised curtain which Dutch artists began to use during the 1640s as an illusionistic device.

As might be expected of such a *tour-de-force*, *A girl chopping onions* was in several famous French collections during the eighteenth century – Gaignat, Choiseul (when engraved), Prince de Conti, Choiseul-Praslin – before entering the collection of Jan Gildemeester in Amsterdam and the Baring collection in London; it was acquired from the latter by George IV.

White, no. 42

GERRIT DOU

(1613–1675)

The Grocer's Shop

Oil on panel
48.7 × 37.9 cm (19¼₆ × 14¹¹⁄₁₆″)
Signed and dated lower right corner:
GDOV (*GD* in monogram) *1672*
RCIN 405542

The Grocer's Shop is a late work, warmer in tone, richer in colour and more expansive in style than *A girl chopping onions*, painted nearly thirty years earlier. The painting was in the collections of the Ducs de Choiseul and Choiseul-Praslin in Paris during the eighteenth century and was acquired by George IV in 1817. Dou had first essayed this theme in 1647 (Paris, Louvre). Its origins lie in sixteenth-century market scenes undertaken by artists such as Joachim Beuckelaer (*c.*1534–74) and Pieter Aertsen (1508/9–75), but Dou here combines several of his favourite motifs, particularly his desire to create a pictorial illusion. The scene is incorporated within a stone arched window with a ledge. Below is a sculpted relief of children playing with a goat, based on the marble executed in Rome by François Duquesnoy (1594–1643; Galleria Doria Pamphili, Rome), of which there is an ivory plaquette in the Victoria and Albert Museum, London. The same relief occurs in *The Poulterer's Shop* (National Gallery, London), which is close in date to the present painting. Although Dou uses an illusionistic device, he in fact distances the viewer from the scene by positioning objects in the foreground and on the ledge. There is, too, a strong sense of narrative, which is not limited to the two principal figures, but extends to the background where a woman (looking directly at the viewer) holding a coffee pot is about to leave the shop, whilst behind her another customer is being served. At this late stage of his life Dou does not differentiate his brushwork so that all the textures are treated evenly – including the impressionistically rendered curtain on the right.

 The type of shop that Dou depicts is eminently respectable and indicates the great success that the Dutch nation had in trading. Market stalls and pedlars still

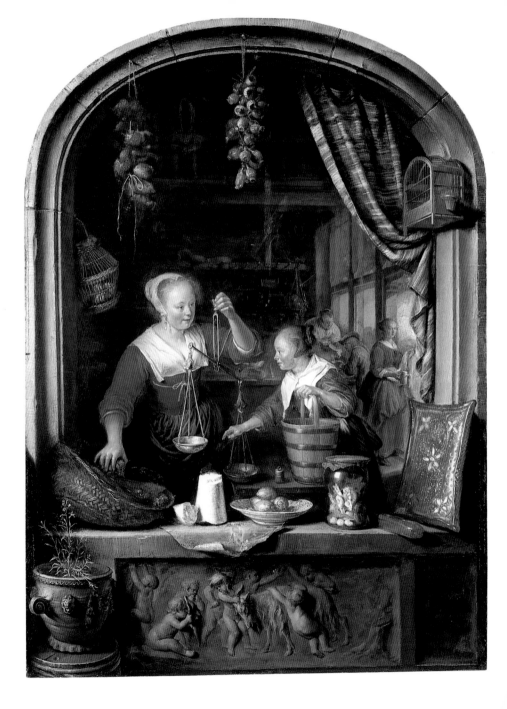

existed, but shops put commercial transactions onto a more formal basis and Dou's compositions have a distinctly domestic feel to them, as though a deliberate extension of the home. The Dutch economy can be seen here at work. He has depicted a general store that sells eggs, dairy products, bread and meat products. There are also exotic goods that show how open the Dutch economy was to imports. The lemons on the ledge are on a blue and white oriental ceramic dish; there are sponges hanging in the arch; and special confections are in a jar on the ledge. At the centre of the arch are poppies used for making syrup, but also associated with apothecary shops. There is in all of this a sense of changing fashion and an opening up to French influence detectable in the style of dress, as well as in the choice of comestibles.

White, no. 46

BARENT GRAAT

(1628–1709)

A family group

Oil on canvas
57.8 × 67.0 cm (22¼ × 26⅜")
Signed and dated lower right: *B.G. f. 1658*
RCIN 405341

The father is seated in the centre of the composition with his arm on a table covered with a carpet. Two of his sons are to the viewer's left, with a third standing behind. His wife is seated to the right of centre with a daughter standing alongside holding a dog. Two other figures are in the composition: one is a servant approaching from behind the group on the left with a jug; and the other can be seen between the columns of the colonnade, leaning on a balustrade contemplating the view. The landscape before which the figures are placed includes in the middle distance farm buildings and a wood. The implication is that this land is owned by the family depicted by Graat. The identity of the family, however, is unknown.

Even so, the purpose of the portrait is clear. It is about the status and wealth of the regent class in Holland. Dress, deportment and setting, with a deliberate contrast being made between the farm buildings and the classical portico, all indicate financial security. The pampered dogs, the carpet covering the table and the glass on the silver salver are further trappings of wealth. The figures have been carefully posed, even ranging in height as in a modern photograph, but Graat's attempt to conceal artifice has led to some awkward passages, particularly in the introduction of the subsidiary figures in the background. Interestingly, the children have been traditionally disposed, with the sons ranged with their father and the daughter with her mother.

Graat spent all his life in Amsterdam. He was a painter of religious and historical subjects and genre scenes, but his speciality was portraiture. His group portraits are often on an intimate scale. Examples of his work are in the Rijksmuseum, Amsterdam, but in Britain he is an exceedingly rare artist.

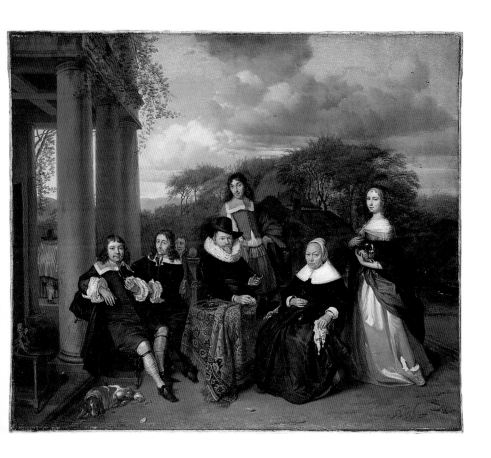

Nonetheless, such paintings as *A family group*, purchased by George IV in 1811, prefigure the development of the conversation piece in British art during the middle of the eighteenth century – for example, William Hogarth (1697–1764), Arthur Devis (1711–87) and early Thomas Gainsborough (1727–86). The figures here are not all that removed in style from those occurring in ter Borch's portraits, with their squat proportions, animated poses and determination to outstare the viewer.

White, no. 55

FRANS HALS

(c.1582/3–1666)

Portrait of a man

Oil on canvas
116.1 × 90.1 cm (45¹¹/₁₆ × 35½")
Inscribed upper right near the head:
ÆTAT SVAE 36/AN. 1630
RCIN 405349

The reputation of Frans Hals is second only to that of Rembrandt in today's assessment of the history of Dutch seventeenth-century art. Unlike Rembrandt, however, Hals was primarily a portrait painter (out of an oeuvre of some 220 works four-fifths are portraits and even his genre pictures have an element of portraiture) and there are no known drawings or prints. The bravura style and confident technique to a certain extent belie the considerable personal difficulties that Hals experienced during his lifetime. Rather like Vermeer's (pages 170–73), it was only during the nineteenth century that Hals's work began to be reassessed and its more modern aspects appreciated. The portrait was acquired either by George III (1738–1820), or, more likely, by his father, Frederick, Prince of Wales (1727–51).

Hals was born in Antwerp. His parents moved to Haarlem in 1591, where he is said to have begun as the pupil of Karel van Mander (1548–1606), the author of the set of biographies of Dutch and Flemish painters entitled *Het Schilder-boeck* (*The Painter's Book*; 1604). He joined the Guild of St Luke in Haarlem in 1610 and received many commissions for group portraits of governing bodies, officers, and members of militia companies, hospitals and charities. At the same time he painted portraits of leading members of Haarlem society from the merchant, regent and professional classes. Although in demand, from 1616 Hals was perpetually in financial difficulties. His first marriage to Anneke Harmensdr (d.1615) should have brought some prosperity through his wife's family, but for some reason he failed to benefit from it. Remarriage in 1617 to Lysbeth Reyniersdr added to his problems since two of the children, Pieter and Sara, had social difficulties. Nonetheless, five of all the children from both marriages

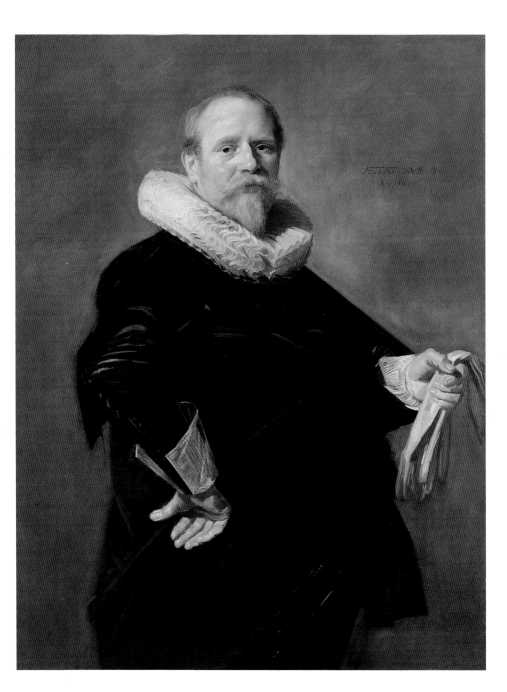

became artists and, in addition, Hals had a number of pupils. Even so, he died in straitened financial circumstances and at the end had to rely on financial assistance from the city authorities, even though he continued painting to the end of his life.

Portrait of a man is striking for its compositional simplicity and tonal unity – both aspects indicative of the artist's stylistic progression during the 1630s. The figure seems to burst out of the lower edge of the canvas. The sense of a strong physical presence is due to the spiral effect created by the jutting elbow on the viewer's left and the hand holding a pair of gloves that extends from the tautened cloth on the right. Gloves held in the hand, as opposed to being worn, are regarded as a gesture of friendship, which in this case is being offered to the viewer.

It is evident that Hals painted very fast, impulsively and fluently, varying the texture of the raised paint surface so that the treatment of the clothes and fabric is in marked contrast with the rather thinly painted facial features. Colour accents are at this stage reduced in value. Hals succeeds in making the impermanent seem permanent and the mobile to be immobile. This illusion is the equivalent of a freeze frame in cinematic technique. Given such visual pyrotechnics and such technical dexterity that increased with the years, it is no wonder that he was so admired in France during the nineteenth century by artists such as Edouard Manet (1832–83) and Vincent van Gogh (1853–90).

White, no. 56

WILLEM CLAESZ. HEDA

(1593/4–1680/2)

Still life on a table

Oil on panel
50.2 × 68.6 cm (19¾ × 27″)
Signed and dated on the knife:
CHEDA. 1638 (*CH* in monogram)
RCIN 404790

Still life as a subject was pursued in Holland to a degree not found in other schools of European painting. No other country produced still lifes in such quantity or to such a high level of competence and so a major development occurred within a specialist category of painting. The love of depicting a seemingly random group of objects demonstrates how people in Holland relished the beauty of the material world – not necessarily as a display of ostentation, but rather for its intrinsic beauty enhanced by simple, direct modes of presentation that had an intimate appeal. There were within still-life painting, however, various categories – including so-called 'breakfast pieces', 'banquet pieces' and 'fruit pieces' – that denoted not only differences in the items chosen for depiction, but also degrees of complexity. 'Banquet pieces' were usually more elaborate compositionally than 'breakfast pieces' and also more vibrantly coloured. On one level still lifes were intended to be a skilful transcription of reality, so that, apart from when there is a reference to a *vanitas* theme, such pictures are generally free from moralising or allegory.

Heda devoted himself almost exclusively to still-life painting and was based at Haarlem throughout his life. Together with Pieter Claesz., he evolved a monochromatic style, portraying – as in the present example – a restricted range of objects: pewter dish, a glass beaker, a rummer, a silver-gilt tazza on its side, nuts, a half-peeled lemon on a pewter dish, a knife, a half-eaten blackberry pie on a larger pewter dish, all set on a table half-covered with a tablecloth. These are composed on a horizontal axis, but certain aspects of the composition, such as the delicately coiled lemon peel, the handle of the knife and the right edge of the table, suggest a sense of recession – just as the two objects poised at the near

edge of the table create dramatic tension. The artist has lavished particular care on the texture of the different surfaces and also, as in the case of the glasses and the pewter, on the reflections. Regardless of the timeless quality of such a composition, it nonetheless seems as though someone has just left the table to allow the artist to begin work. Beyond the representation of the objects, the artist has concentrated on the treatment of light and atmosphere. This is particularly the case with the abstract quality of the wall at the back. As Simon Schama has written, in Heda's pictures 'the objects are so subtly disposed, their relationship with each other so delicately measured, that the least dislodging collapses the whole. The cunning intrusion of the upturned glass or the casually prostrated flagon acts to reinforce the sense of fragility with which this miraculous equilibrium is sustained.' Such still lifes are to be looked at in an 'unhurried, contemplative manner of the humanist scholar rather than the cramming sensuousness of the man of fashion'. After 1640 Heda's compositions are on a larger scale and he begins to use a vertical format and more ornate, reflective surfaces.

A more elaborate still life by Heda with some of the same objects similarly disposed is in the Thyssen-Bornemisza Collection, Madrid (dated 1634). The present painting was acquired by George IV before 1806.

White, no. 58

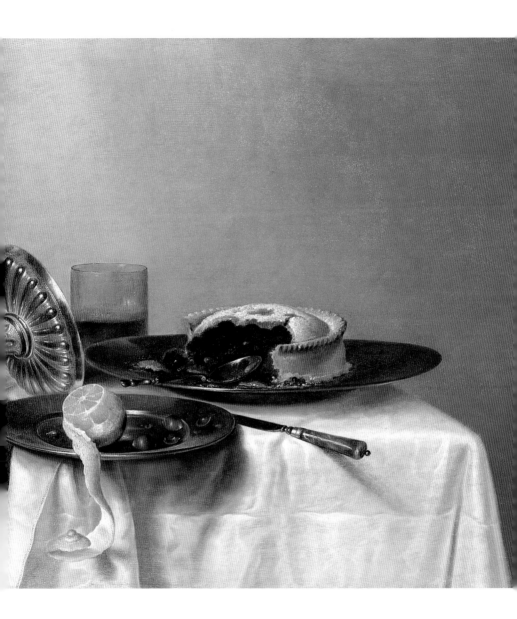

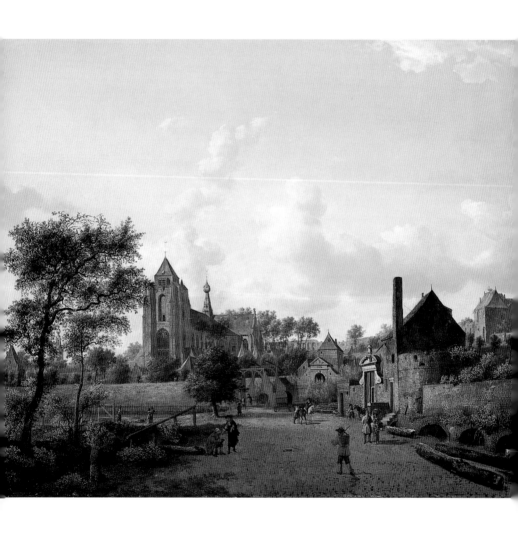

JAN VAN DER HEYDEN
(1637–1712)

The south-west approach to the town of Veere with the Groote Kerk

Oil on panel
45.7 × 55.9 cm (18 × 22″)
Signed lower right corner: *I.V. Heyde*
RCIN 405950

Jan van der Heyden was one of the most prolific and successful architectural painters in seventeenth-century Holland. The tradition of painting views of towns or castles and country houses was part of the process of establishing a national identity for the people of the newly formed United Provinces. The popularity of such pictures coincided with urban expansion as a result of economic success; they were an expression of civic pride. Indeed, when he died the artist had a supply of seventy of his own paintings still in his possession.

Van der Heyden was born at Gorinchem (Zeeland) near Dordrecht, but by 1650 his family had settled in Amsterdam, where he remained for the rest of his life. The places shown in his paintings, however, indicate that he travelled extensively in Holland, Flanders and the Rhineland. Although most of his city views are topographically accurate, some of them incorporate imaginary buildings or rearrangements of buildings. Canaletto, one of van der Heyden's principal successors in this type of painting, did the same in eighteenth-century Venice. Van der Heyden's street scenes are somewhat sanitised, but no less revealing for that, and such subterfuges are perhaps to be expected in paintings that were in all probability intended for sale to a local clientele.

Veere is a town in Zeeland, on a strait between Walcheren and Noord Beveland. It was formerly an important port from which an extensive trade between Holland and Scotland was conducted. In 1686 the Groote Kerk was badly damaged by fire, of which there are no signs in the present picture. Later during the Napoleonic wars both English and French troops were quartered in the church. This view may well have been painted during the 1660s: it is not

known when the artist visited the town. Other views of Veere with the Groote Kerk are in Karlsruhe (Staatliche Kunsthalle), Philadelphia (Museum of Art, Johnson Collection) and The Hague (Mauritshuis). None of these is dated.

Van der Heyden's style has 'an Oriental passion for minuteness' (Kenneth Clark). Houbraken wrote, 'He painted every brick in his buildings... so precisely that one could clearly see the mortar in the joints, and yet his work did not lose in charm or appear hard if one viewed the pictures as a whole from a certain distance'. This style was not restricted to the city views, but is also characteristic of his early landscapes and still lifes. About all these works there is a hypnotic, surrealistic quality that is slightly unnerving – a quality that can also be found in landscapes by some of the Pre-Raphaelites. Van der Heyden's *Room with curiosities* (Svépmüvészeti Múzeum, Budapest) of 1712 is a very extraordinary composition for its date and the fireplace in particular anticipates the world of René Magritte (1898–1967).

The artist was an exemplary citizen and his sense of civic duty extended to installing street lighting and to supervising improvements in fire-fighting practices. The fire hose may have been his invention and was the subject of the treatise entitled *Beschrijving der nieuwlijks uitgevonden en geoctrojeerde Slangbrandspuiten* (Amsterdam, 1690), which he wrote with his eldest son, Jan.

George IV acquired the *Town of Veere* in 1811 and he owned another view by the artist, *A country house on the Vliet near Delft* (*c*.1660) that was in Sir Francis Baring's collection. Both paintings were in French collections during the eighteenth century.

White, no. 65

MEYNDERT HOBBEMA

(1638–1709)

A watermill beside
a woody lane

Oil on panel
53.4 × 70.5 cm (21 × 27⅛")
Signed and dated lower right corner:
M. Hobbema/f. 166[5 or 8]
RCIN 404577

The Avenue, Middelharnais, painted by Hobbema in 1689 and now in the
National Gallery, London, is one of the icons of Dutch art: it is as if the artist had
produced only a single picture and, furthermore, one that was described at the
beginning of the twentieth century as 'the finest picture, next to Rembrandt's
Syndics, which has been painted in Holland' (Hofstede de Groot). In fact, this
pupil of Jacob van Ruisdael had a prolific output, using studio assistants to paint
variations of his compositions and other artists to fill in staffage (background)
figures. There are, however, some strange aspects of Hobbema's life. His real
name was Meyndert Lubbertsz and his use of Hobbema as a name is
unexplained. He is not mentioned in a single literary source during his lifetime.
Although he was close to Ruisdael, who was the greatest landscape painter of the
century, and was seemingly in demand himself as a landscape painter, he died a
pauper. One of the few facts that we do know about Hobbema is that in 1668
he was appointed to a permanent, well-paid post as one of the wine-gaugers of
the Amsterdam toll house. Although this may have restricted his output as a
painter, he did not give up painting altogether.

 Hobbema's favourite landscape motifs are forest scenes with roads, cottages,
watermills and ponds. His appreciation of nature lacks the sombre grandeur and
drama or moral weight of Ruisdael and his compositions are open, light and airy.
Apart from the blue skies and some local colour, his palette is dominated
by greens, browns and ochres. The roads or pathways do not just lead the
eye into the composition in the spatial sense, but also help the viewer
experience the effect of actually moving through the bosky landscape, passing

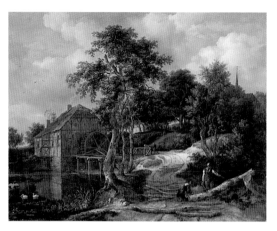

Jacob van Ruisdael, *Landscape with watermill*, 1661
(Rijksmuseum, Amsterdam)

beneath the branches of trees and through dappled patches of warm sunlight.

Hobbema painted watermills on several occasions during the 1660s and may have been inspired to do so by Ruisdael, whose *Landscape with watermill* of 1661 is in the Rijksmuseum, Amsterdam. Only a few of the mills in Hobbema's pictures are specifically identifiable, although many are based on buildings that he may have seen in the province of Overijssel close to the German border. Ruisdael had visited this area *c*.1650 on his way to Bentheim in Germany (see, for example, his *Two watermills and an open sluice at Singraven* of 1650–52 in the National Gallery, London). It seems that Hobbema was not concerned with topographical accuracy, but reused motifs recorded either in drawings or in his memory in an imaginative way. The juxtaposition of mill and house seen on the left appears in two drawings made by Hobbema at Deventer in the province of Overijssel (Teyler Museum, Haarlem, and Musée du Petit Palais, Paris, Dutuit collection). *A watermill* was acquired by George IV with Sir Francis Baring's collection.

Hobbema remained a popular artist for a long time after his death and until recently his reputation unjustifiably eclipsed that of Ruisdael. The subject of watermills in the landscape was one of the favourite themes of François Boucher (1703–70) in the following century and Hobbema's impact on nineteenth-century landscape painting in Europe was also fairly widespread.

White, no. 68

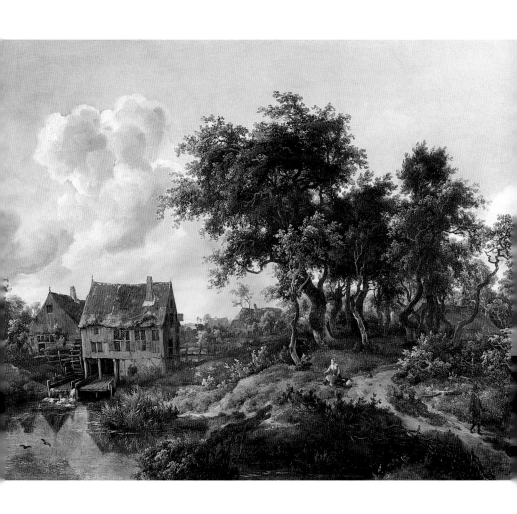

PIETER DE HOOCH

(1629–1684)

A courtyard in Delft: a woman spinning

Oil on canvas
69.2 × 53.4 cm (27¼ × 21″)
Signed lower left corner: P. D. HOOCH
RCIN 405331

Pieter de Hooch is most closely associated with the town of Delft, where he lived for only a relatively short period: from 1652 until c.1660. It was there that he developed the courtyard and interior scenes for which he is best known today. These are characterised by a careful ordering of spatial intervals, often combining interior and external views, striking lighting effects and a precise rendering of physical details. Before his years in Delft, de Hooch had worked in Rotterdam where he had been born, the son of a mason. His training as an artist seems to have been at Haarlem with Nicolaes Berchem, although his early works are mainly of soldiers in taverns or stables in the manner of Pieter Codde or Willem Duyster. After his departure from Delft for Amsterdam his interior scenes during the 1670s become more elaborate, involving numerous figures in more intricate, darker architectural settings, but executed in a broader style with richer colouring. De Hooch died in a lunatic asylum.

An explanation for the artist's change of style in Delft may lie in the example of local artists such as Emanuel de Witte and Carel Fabritius (1622–54), who explored new illusionistic effects through a more rigorous application of perspective. In addition, there was also the presence of Vermeer, whose paintings, however, sought for deeper meanings when contrasted with de Hooch's relatively straightforward transcriptions of reality. To that extent de Hooch's pictures provide a more carefully observed record of life in seventeenth-century Holland than those of his illustrious contemporary.

A courtyard in Delft, acquired by George IV in 1829, is one of the artist's earliest treatments of the theme, dating from c.1657–8. It is also one of the most

atmospheric in the portrayal of the shadows filling the foreground. Thus, de Hooch contrasts the seated figure seen in shadow with the standing figure who is walking from the sunlight into shadow. On the vertical axis there is a similar shift from the bright blue sky overhead to the darker tones in the lower half.

The viewer is invited to enter what is essentially a private world. Both women are preoccupied by their simple domestic tasks. Even so, this private space partakes of a more public context. On the right beyond the house can be seen two towers: the taller one that of the Nieuwe Kerk, where William the Silent, the founder of the Dutch Republic, is buried, and the smaller one that of the Stadthuis. Another important feature of *A courtyard in Delft* is the close observation of the buildings, as regards both the materials from which they are constructed and the tonal relationships (especially the reds) of their silhouetted forms. Most convincing is the patchy distribution of the whitewash on the brick and the different types of mortar and pointing seen in a varying light. The gabled house flanking the tower of the Nieuwe Kerk can be made out in other courtyard paintings by de Hooch, adding to the sense that the artist devised his compositions within a tightly knit area that he knew intimately.

White, no. 84

GERRIT HOUCKGEEST

(c.1600–1661)

Charles I, Queen Henrietta Maria, and Charles, Prince of Wales, dining in public

Oil on panel
63.2 × 92.4 cm (24⅞ × 36⅜")
Signed and dated over the doorway
at the right: HOUCKG... [remainder of
inscription illegible] /1635
RCIN 402966

The interior is almost certainly imaginary (as opposed to being specifically of Whitehall Palace), although the event itself could have been witnessed by the artist, who seems to have been at the English court sometime during the mid-1630s. Charles I owned several paintings by him, or ones in which he collaborated, and clearly admired perspective views of this type. This picture is first recorded in the Royal Collection in the reign of Charles II.

The royal party are seated at a table on the left and are attended by courtiers and servants. A buffet with a display of silver-gilt plate is in the right foreground with an elaborate wine cooler before it on the ground. Attendants carry dishes in and out of the hall through the arch on the right. Those admitted to see the royal family dining in public watch from behind the balustrade forming part of an interior archway in the centre background. Certain aspects of the architecture – the columns, the coffered ceiling, the archway, the overmantel – suggest that Houckgeest was using a print (or prints) as a source. There is a painting in the overmantel and on either side of the arch on the right are two large paintings, possibly landscapes.

The composition provides an interesting record of court etiquette. Public dining in state by the monarch was a frequent practice in the reign of James I (r.1603–25), who liked elaborate spectacle and lavish entertainment, but his son was more private. Charles I rarely dined in public, and when he did so the display of silver-gilt ware was restricted. Unforeseen difficulties tended to arise, such as whether the Anglican or Catholic chaplains should say the prayers

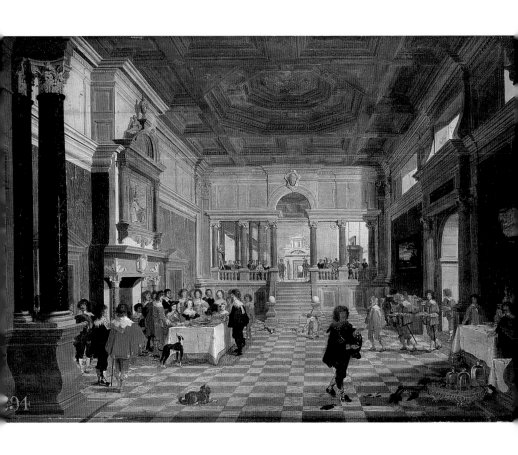

294

– the King was a Protestant, but his wife Henrietta Maria was a Catholic. The custom, with its full ritual, however, was revived by Charles II, who dined in public on three days a week.

This is Houckgeest's earliest-known dated painting. He was born in The Hague, but he had moved to Delft by 1635 and remained there until 1649. During the mid-1650s he moved again, to Bergen op Zoom where he died. He may have been a pupil of Bartholomeus van Bassen (1590–1652), by whom there is a similar painting (*The King and Queen of Bohemia dining in public, c.*1634) in the Royal Collection.

Houckgeest played an important role in the development of painting church interiors as practised by other artists such as his contemporary Pieter Jansz. Saenredam and then by Emanuel de Witte. Although he began by painting imaginary views, after 1650 Houckgeest concentrated on real interiors, using a system of perspective involving two vanishing points.

White, no. 87

Bartholomeus van Bassen,
The King and Queen of Bohemia dining in public,
*c.*1634
(RCIN 402967)

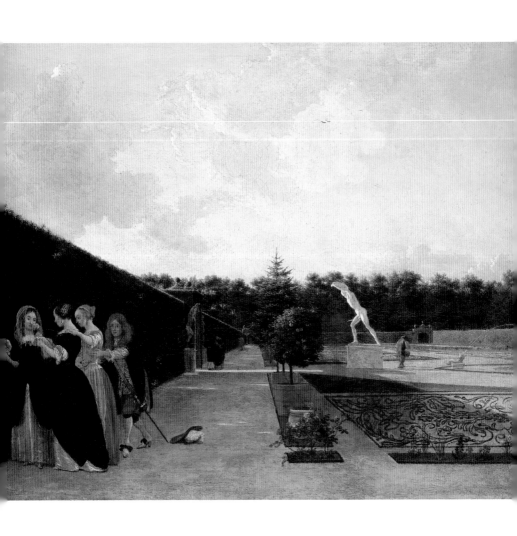

LUDOLF DE JONGH

(1616–1679)

A formal garden: three ladies
surprised by a gentleman

Oil on canvas
60.3 × 74.9 cm (23¾ × 29½")
RCIN 400596

The artist was closely associated with Rotterdam for most of his life, apart from a period of seven years in France (1635–42), and his work was in the past often mistaken for that of another painter from Rotterdam, Pieter de Hooch. It is likely that the younger de Hooch was at first influenced by de Jongh, but by the end of the 1650s the roles had been reversed. Although de Jongh's oeuvre embraced a wide range of subjects, he painted numerous courtyard scenes in both the urban and rural contexts, but without de Hooch's subtle sense of spatial refinement and reflective mood. Instead, de Jongh favours strong narrative and broad characterisation which in a curious way can sometimes anticipate the next century or even nineteenth-century French painting. Occasionally he over-reaches in the handling of perspective or the treatment of light.

It is difficult to interpret exactly what is happening in *A formal garden*, which was acquired by George IV before 1806. To a certain extent it resembles a scene from a play. There is an air of mystery. The principal action is in the lower left corner, where three women are approached by a man. The other figures in the garden ignore this occurrence. There are some idiosyncrasies in this treatment where the action is restricted to the edges of the composition: for example the oversize sculpture (the Borghese Gladiator) dominating the garden and the embroidered effect of the parterre on the right.

A very similar garden, but showing much more of the house on the right and with different statuary, is in the collection of Count Natale Labia in Cape Town. Dated 1676, its subject-matter is equally perplexing. Both paintings depict the grounds of a type of large country house that became popular with wealthy

Dutch families from the mid-seventeenth century. Many were built along the banks of the Amstel and Vecht rivers. Paintings by de Jongh portray the refined life-style associated with these grand country houses. Each of his paintings becomes therefore, in the words of Simon Schama, 'a poem to the Dutch leisure ethic' characterised by 'rustling satin, sleek hounds and afternoon breezes'.

White, no. 94

JOHANNES LINGELBACH

(1622–1674)

A mountebank and other figures before a locanda with a capriccio view of the Piazza del Popolo, Rome

Oil on canvas
63.5 × 72.4 cm (25 × 28½")
Falsely signed lower right: *KDJ*
RCIN 404534

Rome offered Dutch seventeenth-century artists not only associations with the classical past, but also an opportunity to observe aspects of everyday life. For example, Pieter van Laer (*c*.1592–1642), who worked in Rome from 1625 until 1638, specialised in painting street scenes, often depicting the activities of low-life characters. On joining the society of Netherlandish artists in Rome known as the Bentvueghels (birds of a feather), van Laer was given the nickname of Bamboccio (rag doll or puppet), possibly because of a physical deformity to his back, and, accordingly, his followers were known as the Bamboccianti. Amongst those who were influenced by van Laer were Jan Miel (1599–1663), Michael Sweerts (*c*.1618–64) and, particularly, Lingelbach.

Although Lingelbach was born in Frankfurt-am-Main, his family had settled in Amsterdam by 1634, but later he apparently travelled to France before going to Rome – where he is documented in 1647 and 1648. It is not known when he left Italy, but he is next recorded in 1653 in Amsterdam, where he spent the rest of his life. While van Laer's influence predominated during Lingelbach's years in Italy, on his return to Holland he turned more to landscapes, often inspired by what he had seen in the south, and there is a pronounced awareness of the paintings of Philips Wouwermans (pages 184–9).

A mountebank and other figures was acquired by George IV in 1811. It is typical of Lingelbach's work in Rome, even though it was previously thought on the basis of the false signature to be by Karel du Jardin (1626–78). The mountebank dominates the group of figures in the foreground, set in front of a *locanda* (inn).

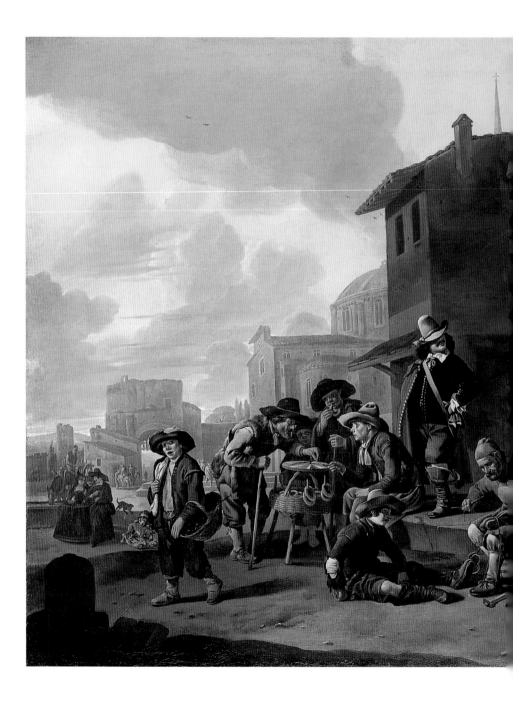

A boy carrying a basket is seen on the left walking away from a group of three men – one of whom sells bread rings (*ciambelle*) – playing a game of *girella*. This involves a grooved wheel which is spun like a top with a piece of string. It was a popular street game in Rome, although it was sometimes banned by the city authorities. A cobbler plies his trade on the step of the *locanda*, at the door of which two beggar musicians are seen performing. A serving girl stands in profile at the door. In the middle distance on the left a couple dressed in Spanish costume lead the eye into the background.

The figures are placed before a topographical background (not wholly accurate) of the Porta del Popolo on the left with the church of S. Maria del Popolo more towards the centre. Aspects of the view are imaginary, but the painter succeeds in evoking the variety of life found on a seventeenth-century Roman street.

Although on a small scale, the figures have a monumentality and a degree of realism associated with Caravaggio. Similarly, the chiaroscural effect, with the dark tones and shadows of the foreground articulated by precisely observed highlights, demonstrates a stylistic allegiance to Caravaggio.

Lingelbach often reused figures, motifs and backgrounds in a number of his paintings.

White, no. 97

NICOLAES MAES

(1634–1693)

The Listening Housewife

Oil on panel
74.9 × 60.3 cm (29½ × 23¼″)
Signed and dated in centre on
lowest step: *N. MAES. A.1655*
RCIN 405535

Maes painted several pictures with moralising themes based on domestic life during the 1650s: for example, *Interior with a sleeping maid and her mistress* ('*The Idle Servant*') (National Gallery, London), *The Listening Housewife* (Wallace Collection, London), *Lovers with a woman listening* (Apsley House, London) and *The Eavesdropper* (Rijksbeeldende Kunst, The Hague), all of which are signed and dated. This one was in France at the end of the eighteenth century and was acquired by George IV in 1811. These paintings are vertical in format with elaborate interiors on different levels and with views through into another room – sometimes two. The principal figure, as here, engages the viewer with a direct gaze and often with an admonitory gesture indicating silence, thereby implicating us in the conspiratorial act of eavesdropping. The eavesdropper was also a popular figure in contemporary love poetry. Maes has used the same model with a similar dress in most of his depictions of this theme. As regards the present composition, the object of our attention is the group in the room beneath the staircase comprising three figures: a couple kissing and an older man carrying a lantern. The painting is essentially a comment on the efficient running of a household. The broom seemingly cast aside at the foot of the staircase suggests that domestic chores have been abandoned in favour of other distractions. The woman's playful smile indicates that she is herself not necessarily being censorious, but in fact encouraging the viewer to enjoy – as she is – the moral dilemma of this particular situation. Sometimes the admonitory gesture is accompanied by one with the other hand indicating the source of concern. There are, in addition, other indications of moral laxity. The pose of the forefinger raised to the lips, representing silence, has a classical origin in

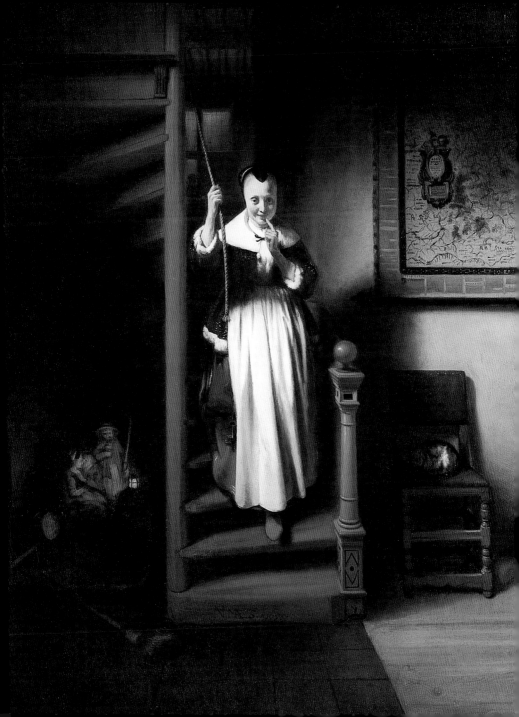

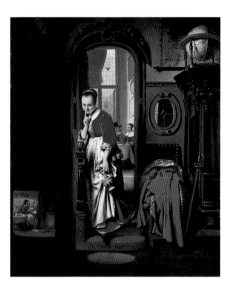

Nicolaes Maes,
The Listening Housewife
(Wallace Collection, London)

representations of Hippocrates, the god of silence, but it was also used during the Renaissance and afterwards for figures of cupids and satyrs seen in compromising situations. The map on the wall, although intended to represent Holland, is a reference to worldliness, whilst the cat asleep on the chair below it is a symbol of wantonness.

Maes was born in Dordrecht, but worked in Rembrandt's studio in Amsterdam in the late 1640s or early 1650s. The rich, warm colouring, the treatment of light and broad characterisation belie the strong influence of Rembrandt, especially in Maes's paintings of older women. Although he returned to Dordrecht, where he married in 1654 and spent a further twenty years of his life, Maes moved back to Amsterdam in the mid-1670s and remained there until his death. There are a few religious paintings from early in his oeuvre, but he then specialised in genre scenes before turning finally to portraiture. Maes is a solid and pleasing painter whose sincerity occasionally edges his genre compositions towards sentimentality.

White, no. 100

GABRIEL METSU

(1629–1667)

The Cello Player

Oil on canvas
63.0 × 48.2 cm (24^{11}⁄₁₆ × 19″)
Signed on the sheet of music held
by the girl: *G. Metsu*
RCIN 405534

A young woman descends a staircase dangling a page of sheet music from her
right hand. She looks down at a young man tuning a violoncello. He is seated in
front of a spinet and rather incongruously wears a hat. Above is another young
man looking on at the proceedings from an arched landing. The young woman's
pet dog greets her at the bottom step. Close examination supported by technical
evidence indicates that the artist changed his mind about the decoration on the
wall immediately above the spinet. At first he placed a picture in that area, the
right half of which included a nude figure while the left half may have been
concealed by a partially drawn curtain. He then painted this out by applying a
thin layer of grey pigment, but a later restorer misread this passage for a hanging
map such as that appearing in Maes's *The Listening Housewife*. This visual
confusion has since been corrected.

The subject of *The Cello Player* is love: the choreographed poses of the two
figures, the emphasis placed on the shared pleasures of music, and the presence
of the dog are the usual ingredients of such a scene. The disconsolate observer,
whose pose is traditionally related to melancholy, is perhaps a frustrated lover.
The underlying sense of dalliance, so knowingly portrayed in the somewhat
languid entrance of the young woman into the room, would also have been
underscored by the painting hanging above the spinet if the artist had chosen
to retain it.

The Cello Player is close in date to *The Musical Party* of 1659 (Metropolitan
Museum of Art, New York), although it is less crowded and is contained within
a less dramatic architectural space. The young woman is based on a model that
occurs in other paintings by the artist, such as *The Letter Writer Surprised* of

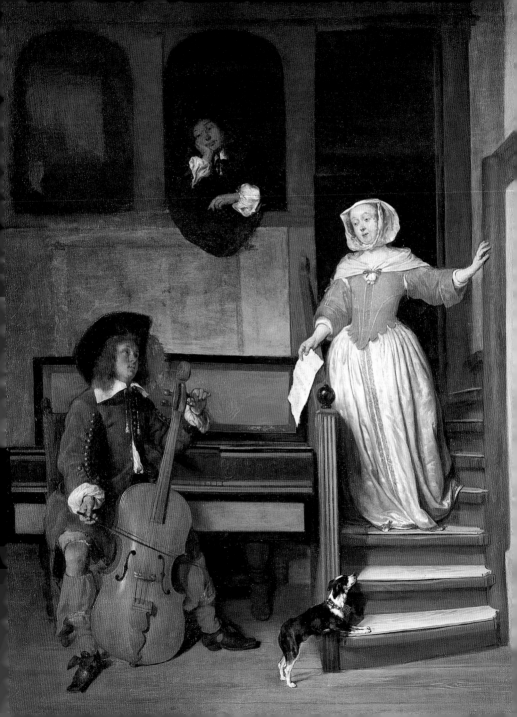

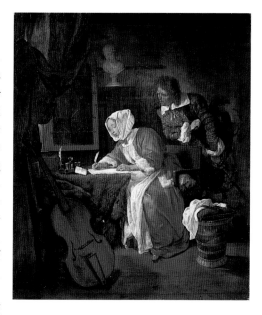

c.1660 (Wallace Collection, London). Metsu pursues two of the themes essayed in _The Cello Player_ in other pictures – a man tuning a musical instrument in _A woman seated at a table and a man tuning a violin_, _c_.1658 (National Gallery, London) and a young woman holding sheet music in _A man and a woman seated by a virginals_ (National Gallery, London), of a similar date. The present painting was acquired by George IV with the collection of Sir Francis Baring, having been in Dutch collections during the eighteenth century.

Metsu was born in Leiden, the son of a painter. He was apparently trained by Gerrit Dou. For the first part of his life he remained in Leiden, where he was a

Gabriel Metsu, _The Letter Writer Surprised_, _c_.1660 (Wallace Collection, London)

founder member of the Guild of St Luke in 1648, but by 1657 he is recorded in Amsterdam, where he married in the following year and eventually died. His paintings are wide ranging in both style and subject, thereby revealing the influence of a number of artists, including de Hooch and Vermeer. Although capable of fine detailed work like ter Borch, he could also paint very broadly as in his unusual interior views of blacksmiths and his game pieces. Genre scenes predominate, but he also painted still lifes, portraits and religious subjects. During the eighteenth century in France Metsu was greatly admired for his narrative skills and was held up as an example for contemporary genre painters to follow. The tendency today is to assert that Metsu did not quite do justice to the dramatic potential in his genre scenes in comparison with ter Borch.

White, no. 101

FRANS VAN MIERIS THE ELDER

(1635–1681)

A girl selling grapes to an old woman

Oil on panel
43.8 × 35.6 cm (17¼ × 14")
Signed lower left: F. v. Mieris
RCIN 406607

The career of Frans van Mieris the Elder was not dissimilar to that of his teacher, Gerrit Dou. Apprenticed first to a goldsmith and then to a glass painter, van

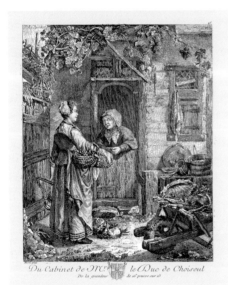

Du Cabinet de M.^r le Duc de Choiseul

Frans van Mieris the Elder, *A girl selling grapes* engraving from *Recueil d'estampes gravées d'après les tableaux du cabinet de Monseigneur le Duc de Choiseul*, 1771

Mieris eventually entered Dou's orbit, joining the Guild of St Luke in Leiden in 1658. Dou called van Mieris the 'Prince of his pupils' and indeed both shared international reputations without ever leaving Leiden. Van Mieris, however, was an intemperate character – often in debt and frequently drunk. Even so, he held positions of responsibility in the Guild of St Luke and increased the fame of the *fijnschilders* by his personal example – to the extent that the style was carried through to the eighteenth century by his two sons and his grandson. He painted mainly genre scenes and portraits, and more traditional narrative subjects less frequently.

A girl selling grapes is an early work dating from the mid- to late 1650s. It is to be presumed that all the produce shown in the picture has been grown on a smallholding and is being sold by the girl

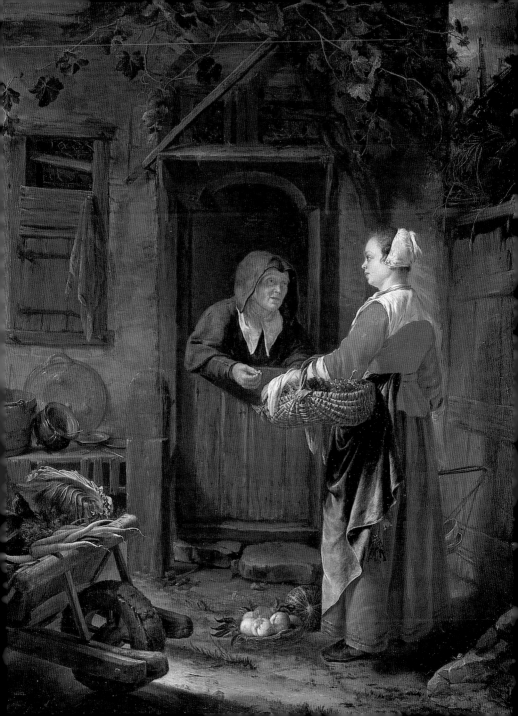

from her wheelbarrow on a house-to-house basis. Such compositions can be found in the work of Dou (*The Herring Seller* of 1654 in Alte Pinakothek, Munich) and Metsu (*The Herring Seller* in Musée Fabre, Montpellier, and *Old Woman selling Fish* of *c*.1660, Wallace Collection, London) where the models are also very similar. It is unlikely that there is any allegorical meaning in the picture, although the different kinds of fruit and vegetable are no doubt intended to refer to the fertility of the Dutch soil and the development of horticulture.

A girl selling grapes was a celebrated work in France during the eighteenth century. It was in the Choiseul (when engraved), Prince de Conti, d'Arveley, and Calonne collections before being acquired by George IV with Sir Francis Baring's collection.

White, no. 110

WILLEM VAN MIERIS

(1662–1747)

An old man and a girl at
a vegetable and fish shop

Oil on panel
38.7 × 32.3 cm (15¼ × 12¹¹⁄₁₆")
Signed and dated top left corner:
W. van Mieris Fec¹ Anᵒ 1732
RCIN 405946

Willem van Mieris was the second son of Frans van Mieris the Elder; his elder brother Jan (1660–90) was also a painter. Trained by his father, Willem van Mieris painted in the traditional style of the *fijnschilders*, achieving an even smoother, more polished surface than his predecessors. Like them he remained in Leiden, where he was prominent in the Guild of St Luke and set up a drawing academy in 1694. He was a prolific artist, painting genre subjects, religious, literary and mythological scenes, as well as portraits and copies of his father's pictures. There are dated paintings for every year from 1682 until 1736, but towards the end of his life he apparently went blind.

An old man and a girl at a vegetable and fish shop, acquired by George IV in 1805, is a 'niche' composition as developed by Dou. The same illusionistic devices are used here – the stone arch with a ledge and a sculpted relief below, with a looped curtain in the arch. Similarly, the artist destroys the illusion by placing objects in the immediate foreground. Immense effort has been lavished on rendering the textures of the different goods on display: dried herrings, gingerbread, walnuts on the ledge; mushrooms and dried fish suspended on either side of the arch; golf clubs and apples in front of the ledge; with additional fruits and gingerbread figures within the shop itself. The painting of the different types of baskets, metal containers and fabrics is a virtuoso display of pictorial skills. A touch of humour is provided by the rat (invisible to the figures in the shop) munching away at an apple at the lower edge, and human interest by the old man and the young woman who engage in their own private dialogue. Even if the brandishing of the clay pipe has erotic overtones, the old man's

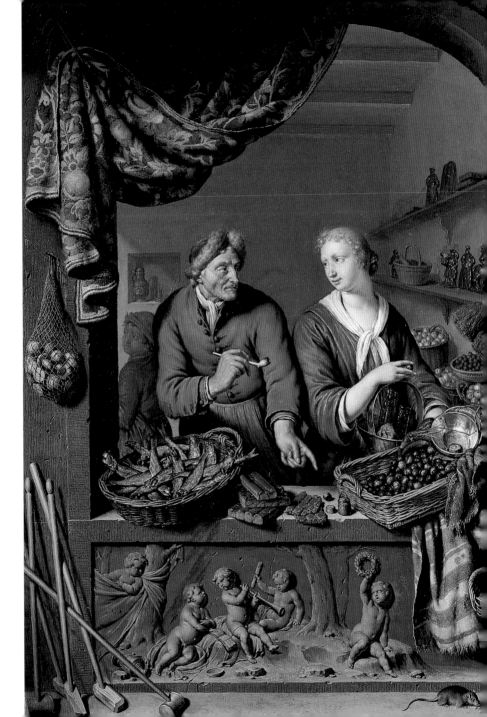

gesture indicating the weights on the ledge is difficult to interpret.

The sculpted relief is reminiscent of that used by Dou in several of his compositions and recurs in other paintings by Willem van Mieris – for example *The Dairy* in the Staatliche Museen, Kassel, of 1705 and *The Grocer's Shop* in the Mauritshuis, The Hague, of 1717. Another relief of tritons and nereids was also used by the artist (see, for example, *A woman and a fish-pedlar in a kitchen*, 1713, in the National Gallery, London). Since Willem van Mieris is known to have made designs for reliefs, it is likely that he used his own imagination rather than copying specific examples.

It has been suggested that *The Greengrocer* in the Wallace Collection, London, might have been a pendant to the present picture.

White, no. 294

WILLEM VAN MIERIS

(1662–1747)

The Neglected Lute

Oil on panel
45.0 × 38.6 cm (17¹¹⁄₁₆ × 15³⁄₁₆″)
RCIN 405543

The subject is one in which Dutch painters were well versed by the beginning of the eighteenth century, when *The Neglected Lute*, which was acquired by George IV with the collection of Sir Francis Baring, was painted. A direct comparison can be made in this book with the paintings by Gerard ter Borch (see page 46) and Gabriel Metsu, although '*The Music Lesson*' by Vermeer is also pertinent. The scene is one of seduction, combining the pleasures of taste, love and music in a suitably grand interior. The man is encouraging the woman to drink whilst her lapdog barks at the black servant entering the room through an arch. The oysters – recognised for their aphrodisiacal qualities – are moist and delicately coloured. The decoration in the room includes some fictitious sculpture, almost a trademark for Willem van Mieris, comprising a statue possibly of the young Bacchus and a relief of gambolling putti. Great care has been lavished on the texture of the various surfaces – the sheen of the silk-satin; the fibres of the carpet; the reflective qualities of silver, glass, wood and mollusc. Above all, there is the theatrical treatment of the light that not only picks out the principal figures, but also creates a feeling of recession into the shadowy background. There is an almost operatic feel to the intensity of highlight striking the underside of the looped curtain at upper left that is reflected across to the cushion covering the stool on the right.

Van Mieris painted variations on this theme, including *The lute player* of 1711 in the Wallace Collection, London. He reused the models in other compositions: the man in *Children's Games* of 1702 in the Wallace Collection and the girl in a number of pictures, including *An old man and a girl at a vegetable and fish shop.* The male model may be a self-portrait of the artist.

White, no. 295

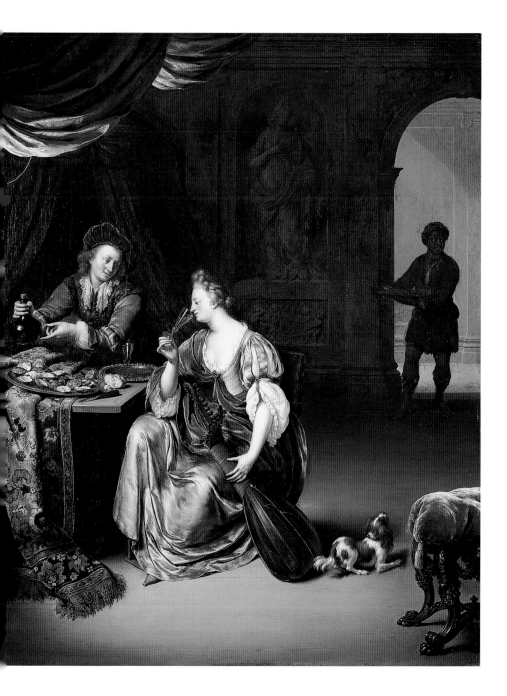

JAN MIENSE MOLENAER

(*c*.1610–1668)

Head of a laughing youth

Oil on panel
49.2 × 38.6 cm (19⅜ × 15³⁄₁₆″)
RCIN 405487

Jan Molenaer was a painter of varying quality. At the start of his career he specialised in genre subjects, often imbued with allegorical meanings, and crowded scenes of merrymakers from different sections of society. At a later stage he seems to have concentrated more on peasant subjects in the manner of Adriaen van Ostade (pages 113–20), but these are often rapidly, if not coarsely, handled. In 1636 Molenaer married the painter Judith Leyster (1609–60). Both artists continued to work independently, although not without signs of financial strain – offset by investment in property in Amsterdam, where they lived during the 1640s, and the Haarlem area, and also by art dealing. *The artist's studio* of 1631 (Gemäldegalerie, Berlin) and *Self-portrait in studio* of *c*.1633 (Private Collection) give an idea of the rumbustious and varied nature of genre painting in Haarlem. It is often said that both Molenaer and Leyster were pupils of Frans Hals. In fact, although it was difficult to avoid the influence of such a robust painter, it is more likely that their stylistic evolution was dependent on Dirck Hals (1591–1656), the younger brother of Frans. The broad handling, strong characterisation and close-up effect with a steep viewing point of *Laughing youth* are typical of the type of painting perfected by Frans Hals in which the formal often abuts the informal. Molenaer would undoubtedly have known of such pictures as the *Laughing boy* of *c*.1620–25 by Hals (Mauritshuis, The Hague), in which the exuberance of both the style and image are perhaps no more than an expression of the sheer joy of living. Usually portraits of children or young people by Haarlem painters depicted the subjects singing, playing a musical instrument or holding a domestic pet, all of which betoken allegorical meanings. *Laughing youth*, dating from *c*.1630, is a spontaneous,

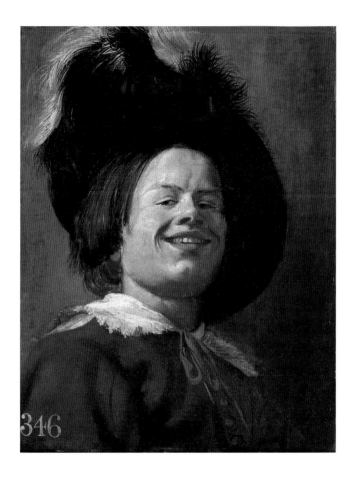

informal portrait, almost certainly uncommissioned. As with works by Hals, its sense of abandon and freedom anticipate later painters such as William Hogarth, Honoré Fragonard (1732–1806) and Edouard Manet.

The painting was acquired by George III in 1762 with the Consul Joseph Smith collection. Previously it may have belonged to the Venetian artist Giovanni Antonio Pellegrini (1675–1741) who was working in The Hague in 1718.

White, no. 116

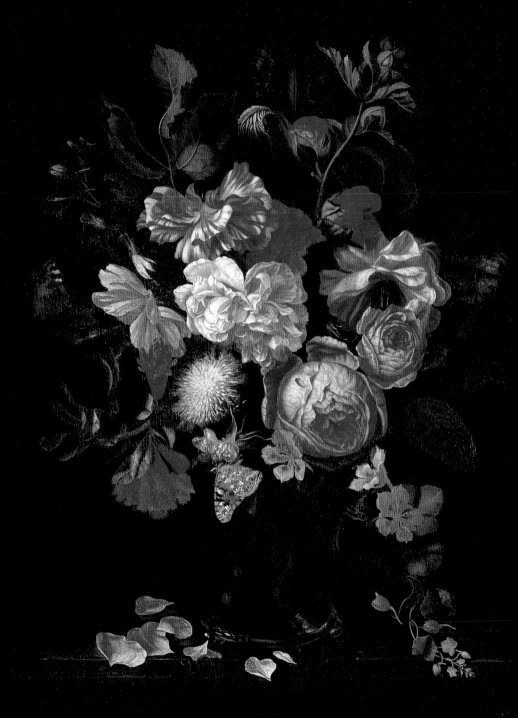

MARIA VAN OOSTERWYCK

(1630–1693)

Still life with flowers and butterflies

Oil on panel
46.4 × 36.8 cm (18¼ × 14½″)
Signed and dated lower right:
MARIA VAN OOSTERWYCK ANNO 1686
RCIN 405626

Flower painting originated in The Netherlands during the sixteenth century, but it became one of the most popular subjects in seventeenth-century Holland and certain artists specialised in this form of still life. Such paintings may have begun as a celebration of Dutch horticulture – an aspect of life in Holland that is still much appreciated today – exemplified at the beginning of the tradition by artists such as Ambrosius Bosschaert (1573–1621), whose compositions are dominated by symmetrically arranged bouquets and amount to a straightforward transcription of reality in a botanical sense. Later in the century, however, in the works of Jan Davidsz. de Heem (1606–83/4), for example, a more expansive (Baroque) style is adopted with complicated overlapping and spiralling of the different forms. More importantly, other elements enter into the presentation – aspects of illusionism (water, drops of moisture, shells, insects) and various symbolic meanings. Several interpretations are based on religious iconography, with different flowers or signs representing Christ's Passion or, more generally, as an acknowledgement of the beauty of God's creation. But when alien elements are depicted – certain insects, snails, dewdrops, a skull – these introduce intimations of mortality or the transitoriness of life. As Mariët Westermann has written, 'Artists and viewers did not find scientific representation incompatible with religious understanding', and often still lifes of flowers were viewed as objects for contemplation, as well as a reminder of the beauty of individual flowers when they were out of season during the winter months. The admiration for such paintings was for 'the creator's ability to forge such a marvellous variety of natural objects and for the artist's capacity to imitate it so convincingly'.

In the present painting, first recorded in the Royal Collection during the reign of Queen Anne (1665–1714), the glass vase rests on a ledge. Several kinds of rose and an iris are identifiable, together with two butterflies. Resting on the ledge are some rose petals to left and a spray of nasturtiums to right. Maria van Oosterwyck has here balanced out the meaning inherent within this still life: the rose petals remind the viewer that beauty must die, while the butterflies refer to Christ's Resurrection.

White, no. 125

MARIA VAN OOSTERWYCK

(1630–1693)

Still life with flowers, insects and a shell

Oil on panel
47.6 × 36.8 cm (18¾ × 14½")
Signed and dated lower left:
MARIA VAN OOSTERWYCK 1689
RCIN 405625

Maria van Oosterwyck, *Vanitas still life*, 1668
(Kunsthistorisches Museum, Vienna)

The glass vase rests on the ledge of a niche. Various kinds of rose are identifiable, as are a carnation, a convolvulus, a ranunculus and a marigold. A bee, a butterfly and a dragonfly have settled on the flowers. A shell is on the ledge to the left of the vase. The painting is dated three years after *Still life with flowers and butterflies*, but it may, nonetheless, have been painted to form a pair with that picture and, like it, is first recorded in the Royal Collection during Queen Anne's reign.

These are the last-known dated works by the artist, who was born at Noorddorp near Delft. The pupil of Jan Davidsz. de Heem and of Willem van Aelst (1625–*c*.1683), Maria van Oosterwyck worked in Delft during the 1660s (retaining a studio there) before moving to Amsterdam in 1673. Her *Vanitas still life* of 1668 (Kunsthistorisches Museum, Vienna) is her most elaborate work and is said to have been undertaken in response to a painting by de Heem. Arnold Houbraken stresses Maria van Oosterwyck's international reputation and records that she sold paintings to Louis XIV, King Augustus of Poland and the Holy Roman Emperor Leopold I. He also states that the artist visited England and so it is possible that the two still lifes in this book were acquired by William III and Mary II. Maria van Oosterwyck's grandfather and father were preachers in Delft and she herself was described as 'unusually pious', which is an indication of how her still lifes should be interpreted.

White, no. 126

ADRIAEN VAN OSTADE

(1610–1685)

Interior of a peasant's cottage:
a child about to be fed

Oil on panel
34.2 × 29.0 cm (13⁷⁄₁₆ × 11⁷⁄₁₆″)
Signed and dated lower right:
Av. Ostade/1651 (*Av* in monogram)
RCIN 406724

Adriaen van Ostade was one of the most prolific painters in seventeenth-century Holland. There are more than eight hundred paintings (often of small dimensions), about fifty etchings and numerous drawings (many with watercolour) by him. He was born in Haarlem, where he lived for all his long life – apart from a short stay in Amsterdam in 1672 following the French invasion of The Netherlands. Van Ostade is recorded in the Guild of St Luke from 1634 and later held high office, as well as belonging to the civic guard company Oude Schuts. He was married twice, the second time in 1657 to a wealthy Catholic woman, Anna Ingels, from Amsterdam. This marriage, together with his huge output, gave him considerable financial security. A portrait of the artist of *c*.1646–8 by Frans Hals (National Gallery of Art, Washington) portrays him as prosperous.

Traditionally, it is said that van Ostade was trained by Hals during the 1620s, but this is unlikely. On the other hand, the inspiration for his life's work may have come from a pupil of Hals, namely the Flemish painter Adriaen Brouwer (1605/6–38), who was in Haarlem until 1631. There are obvious links between Brouwer and van Ostade in subject-matter, but not so much in style since the energetic compositions and expansive brushwork of the former were not sustained by the latter. Through the decades van Ostade became a more poised and subtle painter, creating calmer compositions relying more on tonal nuances than on bright local colours of blue, yellow, violet and rose pink.

Interior of a peasant's cottage was in the Jan Gildemeester collection at the beginning of the nineteenth century and was acquired by George IV with

Sir Francis Baring's collection. The painting pleases by its simplicity. The pyramidal composition is reminiscent of representations of the Holy Family painted during the High Renaissance. Even though firmly anchored as a composition, the way the two principal figures sway outwards creates an internal dynamism that enlivens the scene, just as the treatment of the light entering the room from the window on the left and the unified colours help to characterise the figures. Indeed, both these stylistic features may have been derived from van Ostade's knowledge of Rembrandt.

White, no. 128

ADRIAEN VAN OSTADE

(1610–1685)

The interior of a peasant's cottage

Oil on panel
46.7 × 41.6 cm (18⅜ × 16⅜″)
Signed and dated over the fireplace on right:
Av. Ostade/1668 (*Av* in monogram)
RCIN 404814

This is one of van Ostade's greatest paintings. It is in complete contrast with those representations of bourgeois figures by artists such as de Hooch or Metsu. Having begun by focusing on the rowdiness and boorishness of peasants, by the 1650s van Ostade had chosen to develop a more sympathetic depiction of peasant life. Here he shows a mother holding up a doll for her child to play with, watched by a doting father. An older child eats from a bowl on a stool, closely observed by a dog. The eye then begins to take in all the other details of family life strewn across the floor – the shopping basket, the laundry basket, the children's elaborate chamber pot, the broom, various games, the walking frame. The light comes through the latticed windows on the left, as in van Ostade's earlier picture on a similar theme. At the top an open window suggests that it is summer; it is echoed by the open cupboard door. This is a spacious composition combining a successful application of perspective that leads the eye back into the deeper recesses of the room, tonal nuances that create a sense of atmosphere, and an extraordinary accumulation of realistic detail. The range of objects painted by van Ostade in order to re-create this peasant interior is formidable. The concentration of light on the principal figures is such that only gradually does the viewer realise that there are other figures in the shadowed recesses of the room.

Van Ostade's composition is reminiscent of *The Holy Family* by Rembrandt (Louvre, Paris) of 1640 and further knowledge of Rembrandt

is displayed in van Ostade's etching of a peasant family of 1647. As in Rembrandt's works, it is van Ostade's powers of empathy that bring great distinction to a painting such as *The interior of a peasant's cottage*, and in many respects collectors in the eighteenth century regarded van Ostade's achievement as comparable with Rembrandt's. It was his degree of realism that impressed artists and collectors of the nineteenth century, although from that moment his reputation began to decline. The painting was in the Smeth van Alphen collection in Holland in the early nineteenth century and was acquired by George IV in 1811.

White, no. 132

ADRIAEN VAN OSTADE

(1610–1685)

An elderly couple
in an arbour

Oil on panel
23.2 × 19.4 cm (9⅛ × 7⅝")
Signed lower right corner:
Av. Ostade (*Av* in monogram)
RCIN 404620

The painting is a fine example of van Ostade's ability to depict a wide range of human emotion. It belonged to Sir Francis Baring, and was acquired by George IV. The elderly couple appear to be dressed in costume, possibly dating from the sixteenth century, and may therefore be actors. The figures are pushed right to the front of the composition and the sense of privacy is emphasised by containing them within an arbour, behind which can be glimpsed the more public space in front of an inn. The principal figures are well lit, but van Ostade is clever in building up a sense of spatial recession in passing from the well-lit foreground through a middle distance in half-shadow to a lighter background.

The subject of a man encouraging a woman to drink is a familiar one in Dutch art and this painting should be compared with those by ter Borch and Willem van Mieris included in this book. In these last the intentions of the man are clearly dishonourable; here the interpretation is more humorous. The rueful smiles of both the figures and the playful way in which the man looks out at the viewer suggest that perhaps age tempers, but not necessarily negates, lust. Van Ostade therefore deploys the usual suggestive sexual symbolism such as the clay pipe and the jug. The woman decorously looks away, holding a glass precariously angled in one hand while – perhaps nervously – breaking off a piece of waffle with the other. The age of the two figures imbues the subject with a sense of pathos. The painting of the glass and the jug is particularly fine in both cases, their curvature being emphasised by the highlights.

White, no. 133

ISAAC VAN OSTADE

(1621–1649)

A village fair with
a church behind

Oil on panel
61.0 × 79.4 cm (24 × 31¼")
Signed and dated lower left:
Isack. van. Ostade/1643
RCIN 407234

Isaac van Ostade was the younger brother of Adriaen and died at the age of 28 after a working life of only ten years or so. He was trained by Adriaen, and remained at Haarlem, where he joined the Guild of St Luke in 1643 – the year in which he painted *A village fair*.

Although Isaac at the outset produced peasant scenes, like his brother, he soon devised his own highly individual compositions combining aspects of peasant genre with elements of pure landscape. Subjects such as travellers stopping at wayside inns, and village fairs and winter scenes, became favourite themes that were to be developed further by artists such as Philips Wouwermans. The Royal Collection has two exceedingly fine examples of Isaac van Ostade's art: *A village fair* – acquired by George IV in 1810 – and *Travellers outside an inn*

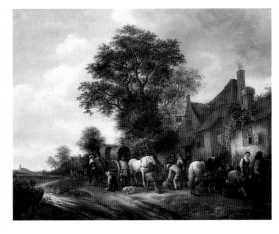

Isaac van Ostade, *Travellers outside an inn*, 1647
(RCIN 407234)

of 1647, which was once in the distinguished collection formed in Amsterdam by Jan Gildemeester. Both paintings have elaborate, intricately woven compositions with numerous figures gathered around a group of buildings.

For *A village fair* van Ostade creates a generous sense of space by setting the figures on a road which serves as a shallow diagonal, countered by another on which the village buildings are set. It is known that Isaac van Ostade made drawings of the villages around Haarlem, but his paintings, unlike Jacob van Ruisdael's, for instance, are based on his own imagination. That, in part, would account for the large proportions of the village church that dominates the right half of *A village fair.*

Isaac van Ostade's way of painting rural scenes was a distinctive contribution to the development of Dutch art, but he was not alone in choosing to depict the countryside. Print makers such as Claes Jansz. Visscher, Willem Buytewech (1591/2 –1624) and Jan van de Velde II (1593–1641) recorded the landscape and villages in the vicinity of Haarlem in a way that openly extolled the beauties of the countryside. Such images were of course intended to appeal to the increasingly urbanised population of Holland. An important aspect of Isaac van Ostade's *A village fair*, however, is not so much the subject as the atmosphere, created not only by the anecdotal interest of the numerous figures, but also by the dampness in the air and the stickiness of the mud underneath. At the beginning of the next century it was Jean-Antoine Watteau (1684–1721) who lifted van Ostade's compositions on to a poetic level.

White, no. 136

CORNELIS VAN POELENBURGH

(1594–1667)

*Shepherds with their
flocks in a landscape
with Roman ruins*

Oil on copper
31.7 × 40.0 cm (12½ × 15¾")
Signed on the broken capital on right: *C.P.*
RCIN 404819

The artist was one of the leading painters in Utrecht, where he was active throughout his life – apart from an important extended visit to Rome from 1617 or before until the mid-1620s. In Rome Poelenburgh was a founder member of the society of Netherlandish artists known as the Bentvueghels (birds of a feather) in whose company he was given the nickname of Satyr (see also page 89). Links between Utrecht and Rome were close as a result of the former retaining Catholicism as its official religion. This connection was reinforced by commercial activities and artistic aspirations.

Poelenburgh's paintings reveal an interest not only in contemporary Roman painting but also in the High Renaissance, which is most evident in his treatment of figures. The artist established a reputation for landscape painting in Rome, where several of his pictures entered important collections. This painting was in a French collection at the end of the eighteenth century and was acquired by George IV with Sir Francis Baring's collection. Poelenburgh also attracted a distinguished clientele, including Cosimo II de' Medici, Grand Duke of Tuscany (1590–1621), Frederick V (1596–1632) and Elizabeth of Bohemia (1596–1662), Frederick Henry of Orange (1584–1647) and his wife Amalia of Solms (1602–75), and Charles I. In addition, Rubens was an admirer.

Shepherds with their flocks in a landscape is an early painting, undoubtedly undertaken in Italy and probably during the early 1620s. While the figures reveal the influence of Poelenburgh's teacher Abraham Bloemaert, the buildings and the setting comprise an imaginary composition suggestive of a mythological

golden age – as evoked, for example, in the poetry of Virgil (70–19 BC), such as the *Eclogues* and *Georgics*, and later Italian poets. Northern artists developed their own Arcadian interpretation, derived in part from the Roman landscape tradition and inspired by the survival of classical architecture and the golden light so characteristic of the Campagna to the south of the Eternal City. Poelenburgh pioneered this type of composition, which Dutch artists continued to portray even after returning from Italy, and in so doing inspired those like Aelbert Cuyp who had never been to the peninsula. Although Poelenburgh's scene is imaginary, the ruin on the right is identifiable as part of the Temple of Castor and Pollux in the Forum in Rome where the well on the left also survived; the background is reminiscent of the Campagna. Overall, however, the setting lacks specificity and the figures seem timeless, moving as though in a dream in the warm evening air.

The artist preferred working on a small scale. His brushwork is precise and his palette unified, relieved by accents of local colour and passages of flickering light. He was a prolific and immensely popular painter who often collaborated with other artists and had a penchant for mythologically inspired themes, as well as for historical and religious subjects.

White, no. 141

FRANS POST

(*c*.1612–1680)

A village in Brazil

Oil on panel
51.1 × 59.1 cm (20⅛ × 23¼″)
RCIN 403542

The Dutch established an empire during the seventeenth century that extended
from the New World to the Far East. It was based on maritime supremacy and
trade centred on Amsterdam. The financial basis of all this international activity
was the Baltic grain trade, which was the prime source of wealth and dominated
the stock exchange in Amsterdam. The most famous institution associated with
Dutch overseas expansion was the East India Company, which by the end of the
century employed twelve thousand people and far outstripped its counterpart,
the Dutch West Indian Company, in importance.

A village in Brazil forms part of an important and fascinating group of works
by Post illustrating the Dutch Republic's interest in Brazil, which it colonised
between 1630 and 1654. Post – together with another painter, Albert Eekhout
(*c*.1610–65), the cartographer Georg Markgraf and numerous observers and
scientists – was invited to join an expedition to Brazil led by Count Johan
Maurits of Nassau-Siegen (1604–79), who served as Governor-General from
1637 to 1644. The expedition resulted in what has been described as 'the most
extensive and varied collection of its kind that was formed until the voyages of
Captain Cook'. Post, who came from a family of artists, made several paintings
and numerous drawings while in Brazil of the buildings, terrain, flora and fauna,
and he continued to paint numerous views of Brazil after his return to Haarlem
in 1644. His drawings and paintings proved to be popular with major collectors
such as Christian IV of Denmark (1577–1648); Frederick William, the Elector
of Brandenburg (1620–88); and Louis XIV, to whom Count Johan Maurits gave
them as gifts. Overall, the material constitutes a unique pictorial record of the
inhabitants of a South American country and it formed the basis of publications

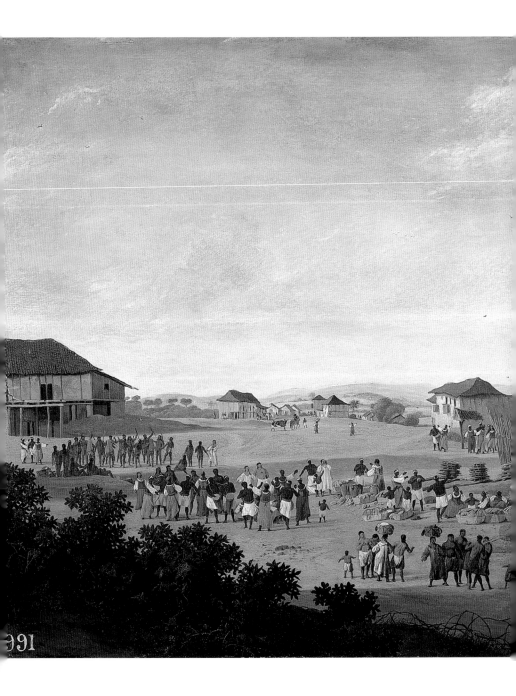

such as *Rerum per octennium in Brasilia* by Caspar van Baerle (1647) and *Historia naturalis Brasiliae* (1648), illustrated with over five hundred woodcuts.

Few paintings by Post survive from his actual time in Brazil, only six of them dated, but it is likely that he did many more. *A village in Brazil* was almost certainly undertaken after Post's return, but might still record a scene witnessed by the artist. Paintings such as this, on a small scale done from life, have an immediacy that anticipates oil-sketches of the nineteenth century – Post's sustained ethnographical interest arising from his travels has been likened (somewhat implausibly) to the work of Henri 'Douanier' Rousseau (1844–1910). The fact that the popularity of Post's views of Brazil was sustained throughout his long life no doubt served as a reminder of Holland's status as a world power, but the significance of his oeuvre is that it amounted to a scientific record as the result of direct observation – as opposed to the more fantastic allegorical representations of the New World painted by artists such as Jan van Kessel (1626–79). The composition and style of *A village in Brazil* and similar works mark a reversion to the orthodoxies of Dutch landscape painting after the more direct approach that characterises those done in Brazil. The scene depicted is a village fair or market.

The painting belonged to the Venetian artist Giovanni Antonio Pellegrini, who no doubt acquired it when he was working in The Hague in 1718. It then passed into the possession of Consul Joseph Smith in Venice, whose collection was bought by George III in 1762.

White, no. 151

HENDRICH POT

(c.1580–1657)

'A Startling Introduction'

Oil on panel
61.3 × 71.8 cm (24⅛ × 28¼")
Signed on the panel on the mantelpiece:
HP (in monogram)
RCIN 405520

Hendrich Pot was in London in 1632, when he painted Charles I (Louvre, Paris) and also a group portrait of the royal family (*Charles I, Henrietta Maria and Charles, Prince of Wales*) which is still in the Royal Collection. 'A startling introduction' belonged to Charles I and was therefore probably painted in London as well.

Pot was almost certainly born in Haarlem and was said to have been a pupil of Karel van Mander, the author of the famous set of biographies of Dutch and Flemish painters entitled *Het Schilder-boeck* (*The Painter's Book*; 1604). He held positions of responsibility (warden and dean) in the Guild of St Luke at Haarlem for several years, as well as serving in the local militia and being involved with judicial aspects of local government, but towards the end of his life he became more closely associated with Amsterdam, where he died. His oeuvre is fairly small, but what survives is varied in subject, extending from large-scale allegories and small-scale portraits to genre subjects of guardrooms or festive scenes sometimes illustrative of low life (for example *A merry company at table* of 1630, in the National Gallery, London).

The subject-matter of 'A Startling Introduction' is easy to describe, but difficult to explain. The woman points a dagger at herself and a man stands back in exaggerated horror, raising his hands and dropping his hat. Clearly he has been in the room for some time – his cloak and sword are placed on the chair seen on the opposite side. Pot has a habit of scattering objects throughout a room as if providing clues in a detective story. Here the broken rose on the ground, the girdle and wine glass on the table, and the hound importuning the lady's lapdog denote an erotic context. The elaborate setting of a room hung with draperies

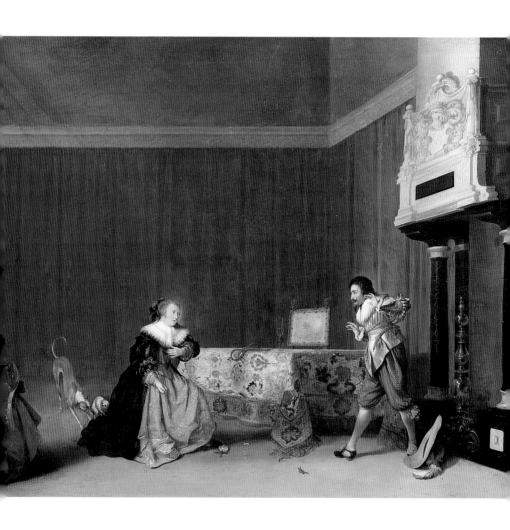

and an armorial mantelpiece (with helmet in reverse) are of no assistance in interpreting the scene. Possibly there is a literary or dramatic source, but the only one so far suggested, *The Palace of Pleasure* by Matteo Bandello (1566) seems too early in date. Other suggestions have been in the realm of historical fantasy and were no doubt encouraged by Pot's somewhat operatic treatment of the subject. Indeed, in many respects the painting anticipates the historical genre scenes of J.L.E. Meissonier (1815–91) in nineteenth-century France.

White, no. 153

REMBRANDT VAN RIJN

(1606–1669)

An old woman
('The Artist's Mother')

Oil on panel
61.3 × 47.3 cm (24⅛ × 18⅝")
RCIN 405000

The painting was presented to Charles I by Sir Robert Kerr (later 1st Earl of Ancram), together with two other works also then thought to be by Rembrandt. These were the first pictures by the artist to enter a British collection. Apart from 'The Artist's Mother', the other paintings were almost certainly Self-portrait (Walker Art Gallery, Liverpool) and Young scholar by a fire (now lost) which was probably not by Rembrandt but by his friend and rival, Jan Lievens (1607–74). Sir Robert Kerr had been sent to Holland in early 1629 as a special envoy for Charles I on a mission of condolence to The Hague after the death by drowning of Charles's nephew Frederick Henry, the eldest son of Frederick V and Elizabeth of Bohemia. It is possible that ultimately the paintings were a diplomatic gift from the Stadtholder, Prince Frederick Henry of Orange, or indeed from his secretary, the scholar Constantijn Huygens, acting on the Stadtholder's behalf. Alternatively, Sir Robert Kerr may have obtained the pictures for himself and then presented them to Charles I. Whatever the circumstances were, the links between Kerr and Huygens are clear. Huygens was one of the earliest supporters of Rembrandt and Lievens; Kerr, a keen supporter of Charles I and for many years a member of his household, remained in contact with Lievens after the Civil War when he was living in exile in Amsterdam; and both men admired the poetry of John Donne.

'The Artist's Mother' is a study in old age by a young, aspiring painter who rapidly gained a reputation for this kind of work before moving to Amsterdam to develop his career as a portraitist and history painter. Executed towards the end of his time in Leiden (c.1629), this painting already reveals Rembrandt's mastery

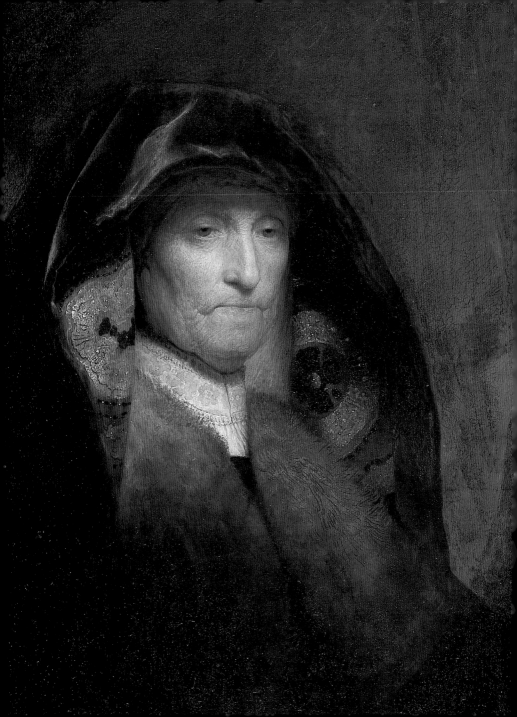

of precise detail in the treatment of the folds of skin, the sunken eyes, the taut mouth and the prominent nose. The figure wears an exotic deep purple hood with a fur mantle over a dark dress culminating in an embroidered white chemise. The tone of the painting is sombre, but it is offset by the parchment pallor of the skin, the colour of the chemise and the yellow embroidery of the hood. The treatment of the light falling from the right of the composition directly onto the face is masterly in the way it focuses the viewer's attention on the features.

Rembrandt often used his mother, Neeltgen Willensdr. (*c*.1568–1640), as a model at the outset of his career in both paintings and prints, but not strictly in terms of conventional portraiture. '*The Artist's Mother*' falls into the category of studies of elderly people usually portrayed at bust or half-length and known as *tronies* (a generic term for 'face'). Such paintings move beyond the realistic imitation of old age to become exercises in imagination incorporating the use of costume and vivid lighting effects. As such, young artists undertook these paintings in order to establish their reputations and accordingly they were much sought after by collectors. Both Rembrandt's colleague Lievens and his first pupil Gerrit Dou used the same type of figure in paintings of a similar date.

X-rays show that the image has been painted over an earlier portrait of an old man seen the other way up and possibly intended for a biblical figure. Interestingly, the artist also reused the panel in Liverpool to paint his self-portrait (see also pages 140–43).

White, no. 158

REMBRANDT VAN RIJN

(1606–1669)

Christ and St Mary Magdalene at the Tomb

Oil on panel
61.0 × 49.5 cm (24 × 19½")
Signed and dated indistinctly on the tomb
on the right: *Rembrandt f¹.1638*
RCIN 404816

The painting reveals how imaginatively Rembrandt could interpret traditional religious subject-matter. The scriptural source for this scene is the Gospel of St John (20:11–18), which describes in some detail the burial and subsequent resurrection of Christ following the Crucifixion. Mary Magdalene returns to the tomb early the next morning, only to find the stone at the entrance removed and two angels inside it where the body should have been. She then fetches two of the disciples, who check that the tomb is empty and then leave her. The angels then ask Mary Magdalene, 'Woman, why weepest thou?' and she replies, 'Because they have taken away my Lord, and I know not where they have laid him.' At that moment she turns round and sees a man dressed as a gardener, not appreciating that he is the resurrected Christ. She appeals to him for information, but he calls her by her name and she instantly recognises him. ('Jesus saith unto her, Mary. She turned herself, and saith unto him, Rabboni; which is to say master.') Rembrandt has depicted the moment of realisation just before the actual recognition. Most artists chose to paint the next moment in the text, when Mary Magdalene reaches out towards Jesus and he forestalls her with the words 'Touch me not' (in Latin, *Noli me tangere*).

This distinction is borne out by a reference to Rembrandt's painting in a contemporary poem by a friend, Jeremias de Decker (1609–66), entitled 'On the representation of the risen Christ and Mary Magdalene, painted by the excellent Master Rembrandt van Rijn, for H.F. Waterloos' and published in an anthology of 1660. In the second stanza de Decker refers to the saint as hovering 'twixt joy and sorrow, fear and hope' after Christ speaks to her.

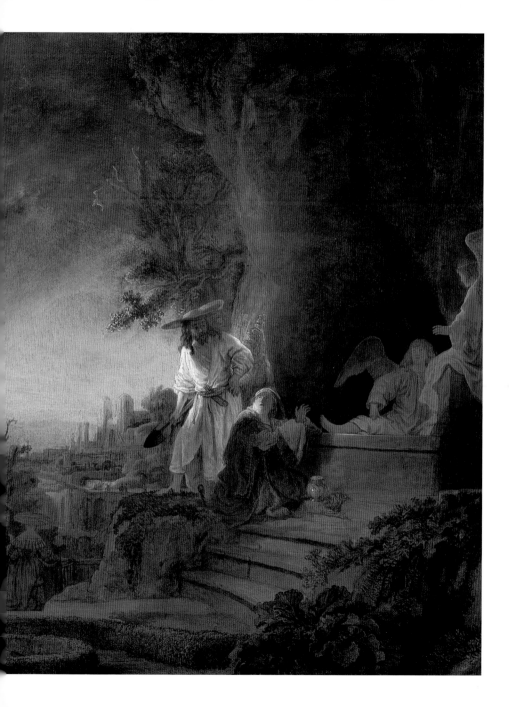

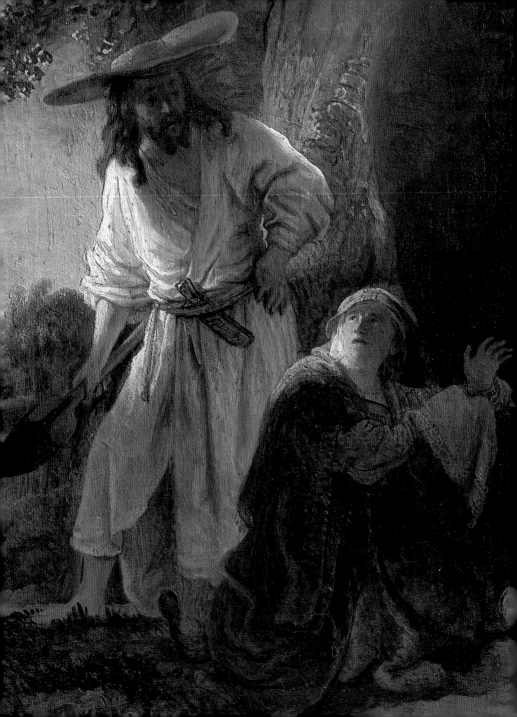

Rembrandt skilfully evokes the dawn as the opalescent light picks out from the darkness the towers of the Temple of Jerusalem, the upper half of the figure of Christ, the face of Mary Magdalene, and the outline of one of the angels in the tomb. This use of light is almost symbolic in both the physical and the spiritual senses. The paint is in general thinly applied and, apart from the treatment of the light and the vegetation around the tomb (referring to Christ's activities as a gardener), could almost be described as monochrome. It is only after a time that the eye focuses on the two female figures (the Gospels of St Mark and St Luke refer to three Maries at the tomb) in the middle distance on the left descending the hill.

Of particular note is the positioning of Christ, who in the relationship established between his partially silhouetted vertical form and the Temple of Jerusalem behind and the rocky cave next to him dominates the composition, whereas the twisting pose of Mary Magdalene is the pivot. The tension created between Christ's standing figure and the twisting, kneeling Mary Magdalene is palpable. The artist's only other treatment of the subject of Christ and Mary Magdalene is in Brunswick (Herzog Anton Ulrich Museum): it is dated 1651 and is totally different in composition.

The provenance of the picture in the Royal Collection can be reliably traced to Holland from the beginning of the eighteenth century. It was later in the collection of Landgrave Wilhelm VIII of Hesse (1682–1760) at Kassel, but was removed from there in 1806 for the collection of the Empress Josephine (1763–1814) at Malmaison in France. It was sold by her son, Eugène de Beauharnais (1781–1824), enabling George IV to acquire the painting in 1819.

White, no. 161

REMBRANDT VAN RIJN

(1606–1669)

Portrait of Rembrandt
in a flat cap

Oil on panel
70.5 × 57.8 cm (27¾ × 22¾")
Signed and dated on the right by
the shoulder: *Rembrandt. f. 1642*
RCIN 404120

It is not perhaps surprising that the greatest artist of seventeenth-century Holland should have been so self-indulgent in depicting his own likeness. Other artists in subsequent centuries – Sir Joshua Reynolds, Vincent van Gogh and Pablo Picasso (1881–1973) – have painted several self-portraits, but arguably they did not transform the form into such a powerful means of artistic self-expression. Rembrandt literally paints his autobiography by means of some forty pictures, as well as thirty-one prints and numerous drawings.

Rembrandt was born in Leiden, the son of a miller, and for a short time attended the university there. Having decided to become a painter, his first apprenticeship was to Jacob Isaacsz. van Swanenburgh (*c.*1571–1638) in Leiden and then to Pieter Lastman (1583–1633) in Amsterdam, but his progress was so rapid that he was able to set up on his own in 1624–5, when he was in close contact with Jan Lievens, and even started taking pupils such as Gerrit Dou. Success in Leiden was, more importantly, followed by success in Amsterdam, where he moved in 1631–2 and gained an unrivalled reputation as a portrait painter before broadening his repertoire to include religious, historical and mythological pictures. On arriving in Amsterdam he established an association with an art dealer, Hendrik van Uylenburgh, whose niece Saskia he married in 1634. She was from a wealthy Frisian family and the marriage resulted in four children, of whom only one, Titus, survived. Now at the height of his success, Rembrandt bought a large house in

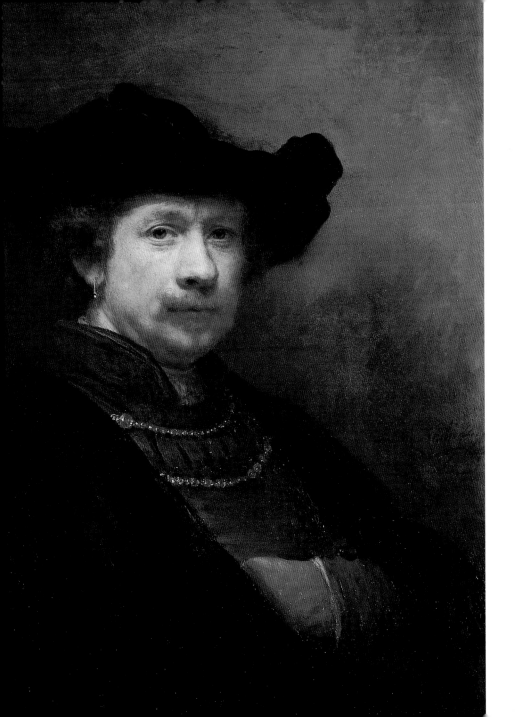

Amsterdam, but later this was to exacerbate his growing financial difficulties. Saskia died in 1642, the year of *The Night Watch* (Rijksmuseum, Amsterdam), and in 1649 Rembrandt entered into a lifelong relationship with Hendrickje Stoffels. Because of a stipulation in Saskia's will, they never married. This created personal problems, particularly after the birth of their daughter Cornelia, and the situation was compounded by the artist's financial difficulties – leading in 1656 to a declaration of insolvency and shortly after that to the sale of his art collection. During the 1660s Rembrandt never recovered from this setback: he was forced to sell off Saskia's grave in the Oude Kerk and at the end relied on his daughter's savings. Both Hendrickje Stoffels and Titus died of the plague, in 1663 and 1668 respectively, and when Rembrandt himself died he was buried in an unknown rented grave in the Westkerk, Amsterdam.

Rembrandt's contribution to art was based on his unequivocally human treatment of a variety of subject-matter and his highly individual method of painting. The first of these qualities could not be taught, but the second could and during the 1630s Rembrandt had a number of pupils who became important artists in their own right. By the 1650s and 1660s, however, Rembrandt's style was too individual and too challenging to be imparted to others and he became an isolated figure. His total oeuvre comprises paintings, prints and drawings – all in considerable numbers.

The self-portrait in the Royal Collection is dated 1642, when the artist was aged 36, and was acquired by George IV with Sir Francis Baring's collection. It is comparable in many respects with the self-portrait of 1640 in the National Gallery, London, although without the ledge along the lower edge of the composition. Technical investigation of the present panel has revealed that it was used on at least two earlier occasions by the artist for self-portraits: once as early as the beginning of the 1630s and again later towards the end of the same decade. This, together with the fact that the surface as it now is was once overpainted, has clouded judgements about the painting's status. The execution of the flesh tones and the panache with which the cap has been painted do, however, provide ample evidence of the autograph quality of the picture. As so

often in his self-portraits, Rembrandt has put on fancy dress – at least to a degree. The chains and the earring are no doubt part of this playful self-presentation and it is also significant that the front of the cap was once decorated with a looped chain as in the National Gallery self-portrait. Where for the image of 1640 Rembrandt adopts a persona taken from Italian Renaissance sources – Raphael or Titian (*c*.1488–1576) – here he depicts himself in a direct way as a confident, successful man of the world. He exudes gravitas, but is instantly likeable: his troubles have yet to overwhelm him.

White, no. 168

SALOMON VAN RUYSDAEL

(c.1600/3–1670)

A river landscape
with sailing boats

Oil on panel
44.5 × 67.9 cm (17½ × 26¹¹⁄₁₆″)
Signed and dated on the rowing boat
in centre: *SVR* (*VR* in monogram) *1651*
RCIN 405517

Salomon van Ruysdael was the uncle of the more famous Jacob van Ruisdael whose paintings, according to J.W. von Goethe, 'satisfy all the demands that the senses can make of works of art' and whose landscapes so impressed John Constable. Yet Salomon van Ruysdael holds an important place in the evolution of Dutch landscape painting in his own right. His works reveal the influence of Esaias van de Velde (*c.*1591–1630), Peter Molijn and Jan van Goyen, with whom he lays the foundations for the greatest period of the art of Dutch landscape painting during the 1650s and 1660s.

Van Ruysdael was born at Naarden just to the south-east of Amsterdam, but lived all his life in Haarlem, where he is first recorded in the Guild of St Luke in 1623. His early paintings are landscapes of the dunes and genre subjects of travellers outside wayside inns, but during the 1640s he specialised to good effect in river views. At the end of his life he painted still lifes. Although he was based in Haarlem, it is apparent that van Ruysdael travelled quite extensively in Holland.

A river landscape with sailing boats is a fine example of van Ruysdael's own individual contribution to seventeenth-century Dutch landscape painting. Its early history is unknown and it is first recorded in the Royal Collection in 1849. The composition is almost shocking in its simplicity, with low horizon line, towering sky, wide river and strip of land with houses surrounded by trees. Indeed, the breadth of the river is such that it might almost be an estuary and the variety of craft provides a purposeful aspect that is characteristic of rivers when they reach the sea. The style is tonal and in this case almost

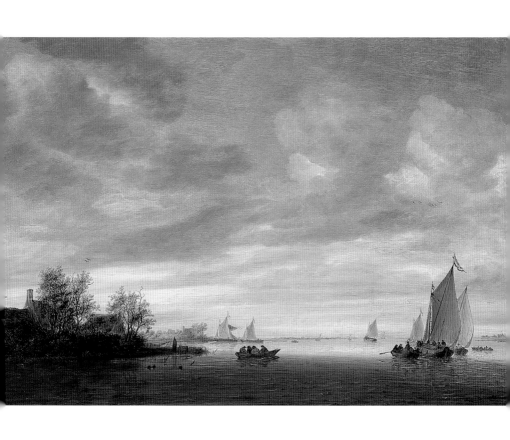

monochromatic. The sky is broadly brushed, but the ripples of the water, the shadows, the foliage of the trees, and the rigging of the sailing boats are treated in greater detail.

There is a languorous feeling about *A river landscape*. The gentle diagonal of the bank on the left meets the other formed by the sailing boats on the river far away in the distance, which stretches beyond that point into the realm of infinity. The cloudy sky fills the foreground with shadows, but the sun illuminates the middle distance and the horizon. By such means van Ruysdael lifts the mundane onto the level of poetry. He is, in essence, a painter of frozen time. Only the German painter Caspar David Friedrich (1774–1840) in the nineteenth century could evoke such a sense of stillness in nature and by the use of symbolism lift the particular onto the level of the universal. It was to van Ruysdael's great credit that he divined the universal in the particular.

White, no. 173

GODFRIED SCHALCKEN

(1643–1706)

The game of 'Lady, Come into the Garden'

Oil on panel
63.5 × 49.5 cm (25 × 19½")
Traces of a signature which was formerly
read as: *G. Scalcken me fecit*
RCIN 405343

The painting is described by Arnold Houbraken, a pupil of the artist, in his book on Dutch artists published in 1718–21. He identifies the subject and records that the central figure seated on the ground is a portrait of Schalcken himself. The female figure against whom he rests is, on the same authority, his sister Maria and on the far left is his future wife, Francoise van Diemen. These identifications can be corroborated by other portraits. Houbraken saw the painting in Dordrecht when it was in the collection of Johan van Schuilenburg. It was said to have been in the collection of Louis XVI (1754–93) at the time of the French Revolution and was bought by George IV in 1803.

Although Houbraken referred to the game by its title 'Lady, Come into the Garden' (*Vrouwtje kom ten Hoof*), he did not really explain what it entailed. Apparently, it was popular with young people in Dordrecht at the time the picture was painted, *c*.1665–70, and it clearly involved the removal of clothes. The male figure shrugs as if to indicate how powerless he is in the hands of the women surrounding him. There are two possible interpretations of the meaning of the game. One refers to whether the man or the woman has the dominant role in a domestic household – literally who wears the trousers. The other is based on an illustration in an emblem book by Johan de Brune, *Emblemata ofte sinnewerck* (Amsterdam, 1624). In this a man loses his clothing while cavorting with two young women and the accompanying text cautions men against any of those women who are intent upon seeking their own pleasure: 'Because she is a woman and she is full of cunning. / Whoever might be the God of this type of woman, / He has given us a sea of misery.'

The painting is an early work by Schalcken, who was trained first by Samuel van Hoogstraten (1627–78) and then by Gerrit Dou – both pupils of Rembrandt. Although he is recorded in The Hague, he is most closely associated with Dordrecht. He also worked farther afield, in London (1692–7) for William III and in Düsseldorf (1703) for the Elector Palatine, Johann Wilhelm. Schalcken painted biblical and mythological subjects, as well as genre scenes and portraits. He also made prints and there are several drawings by him. To a large extent his reputation rested on his night scenes illumined by candlelight, but he followed the Leiden tradition of giving his pictures a smooth, highly finished surface, notable in *The game of 'Lady, Come into the Garden'* in the treatment of the various fabrics.

White, no. 180

JAN STEEN

(1626–1679)

*A scene in a peasant
kitchen with a servant
laying a cloth*

Oil on canvas
71.2 × 63.5 cm (28½ × 25")
Signed on the back of the door:
J Steen (*JS* in monogram)
RCIN 405297

Steen was a consummate narrative artist who painted several mythological and biblical subjects, but is seen at his best in genre scenes. These are not always straightforward and often illustrate aspects of human folly or vanity, usually by reference to well-known Dutch proverbs of the time or emblem books. Such scenes, often laced with humour, are frequently crowded with figures woven together in intricate compositions that are usually moralising in intent. Although Steen painted the whole gamut of human emotions, he also depicted landscape backgrounds and included a wide range of domestic utensils or furnishings in his pictures, as well as achieving a meticulous finish in the handling of fabrics. He closely identified himself with his work by including numerous self-portraits.

The artist was born in Leiden, the son of a brewer – brewing is a trade with which he himself became involved, even though early on he studied for a short time at the University of Leiden. He was a founder member of the Guild of St Luke at Leiden in 1648, but was at Haarlem infrequently from 1661 until 1670, when he returned to Leiden, where he kept an inn. His training was varied: Jan van Goyen at The Hague, Nicolaes Knüpfer (*c.*1609–55) at Utrecht and Adriaen van Ostade at Haarlem. He was a prolific painter, balancing out breadth of style with a careful finish, and some of his compositions anticipate developments in genre painting in eighteenth-century France.

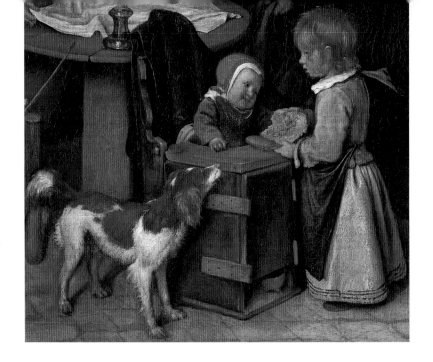

Although George IV acquired seven of the paintings by Steen in the Royal Collection, *A scene in a peasant kitchen* belonged to Consul Joseph Smith, whose collection was bought by George III in 1762. It is difficult to interpret, although it is evident that the seated woman and the standing man holding a clay pipe in the centre might be visitors being offered hospitality. The wicker bird-cage hanging from the ceiling represents conjugal felicity and so Steen may not have intended this picture to have a critical dimension. The scene in the foreground of the small boy offering the child some bread watched by the ever-vigilant dog is a vivid image.

The painting probably dates from the artist's time in Haarlem when the influence of Adriaen van Ostade re-enters his work – as comparison with *Interior of a peasant's cottage* demonstrates (page 113).

White, no. 188

JAN STEEN
(1626–1679)

A woman at her toilet

Oil on panel
64.7 × 53.0 cm (25½ × 20⅞″)
Signed on left-hand column: *JSteen*
(*JS* in monogram) and dated on right-hand
column: *1663*
RCIN 404804

The painting is an outstanding example of Jan Steen's art in all respects. The elaborate treatment of subject-matter reveals a profusion of references that would have been readily recognisable to his contemporaries, attesting to the painter's intelligent use of symbolism.

A young woman is shown partially undressed, with an unlaced jacket, putting on a stocking. A lapdog lies on her unmade bed, by which there is a chamber pot, and her shoes are scattered on the floor. The figure is alluring and looks straight out at the viewer with an inviting expression. Seduction is her intent. The viewer, however, is kept out of the room itself, which lies beyond an imposing arched doorway imbued with classical features. Two columns with Corinthian capitals rest on bases decorated with cartouches, whilst the arch itself is adorned with swags and a weeping cherub. There is a marked and deliberate contrast between the interior and the exterior, to the extent that *A woman at her toilet* is clearly to be read as an allegorical painting. The arched doorway is a threshold that no sensible person should cross, however strong the temptation. The arch represents moral probity emphasised by the symbolism of the sunflower (constancy), the grapevines (domestic virtue) and the weeping cherub (chastised profane love). Once in the room, the viewer is confronted by a host of *vanitas* objects: a lute with a broken string, a skull intertwined with a vine, a candle with the flame extinguished, and a jewellery box with its lid wide open. These all signify the transient effects of misdirected sensual pleasure. Even the act of pulling on a stocking had a clear message, which is found in the emblem book by Roemer Visscher, *Sinnepoppen* (1614): namely that impetuous behaviour

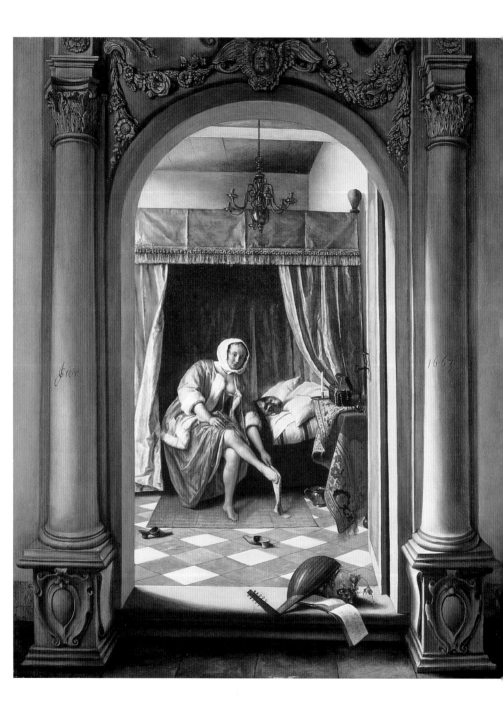

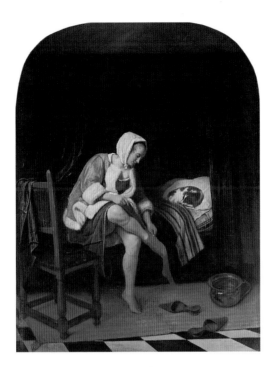

Jan Steen, *Woman at her toilet*, c.1659–60
(Rijksmuseum, Amsterdam)

such as pulling on a stocking too quickly could result in its being holed, just as yielding to sensuality could lead to ruin. Steen implies that to pass through the arch would be to risk the loss of virtue. There is, therefore, a sense in which the interior amounts to pagan love and the exterior to spiritual love. The artist's ingenuity does not end with the images, but extends to word play: the Dutch word for stocking (*kous*) used as slang meant fornication and the Dutch word for chamber pot (*piespot*) used in conjunction with *kous* (i.e. *pieskous*) was in slang a pejorative word for women. Similarly, to appreciate the significance of the artist's signature on the column it is necessary to realise that *steen* in Dutch means stone.

On a technical basis, the quality of the painting is remarkable for the treatment of the light, particularly in the room itself, and in the meticulous depiction of the still-life objects (the bed, the floor, the ceiling, the chandelier) and the foreshortening of the door.

A woman at her toilet was in private collections in Amsterdam and Brussels during the second half of the eighteenth century. It was acquired by George IV in 1821. A variant of the composition from *c*.1659–60 in the Rijksmuseum, Amsterdam, emphasises the narrative elements and eschews allegory.

White, no. 189

JAN STEEN
(1626–1679)

A Twelfth Night feast:
'The King drinks'

Oil on panel
40.0 × 54.0 cm (15¾ × 21¼")
Signed lower right corner: *JS*
RCIN 407489

The subject of the painting is the celebration of Twelfth Night (6 January), the Feast of the Epiphany, when the three kings travelled to Bethlehem to offer gifts to the new-born Christ Child. In Holland the feast is known as *Driekoningenaroud* and originated in performances of the plays devised around the story of Herod organised by the *rederijkers* (chambers of rhetoric). Twelfth Night was therefore a religious festival of Catholic origin retained in Protestant Holland, mainly as a secular festival reuniting the family in a special celebration. The tradition was that each family chose a 'king' for the occasion, either by drawing lots or else by means of a bean or silver coin concealed in a loaf or cake. The 'king' then processed from the house, followed by children wearing baskets on their heads and with figures representing the Fool and the Glutton in grotesque costumes, together with other members of his 'court'. Songs referring to Herod and the story of the three magi were sung. Later, the procession made its way to a tavern or returned to the house for further celebrations. Details of the proceedings differed according to town. The 'king' was not necessarily meant to represent one of the magi but, as here, might refer to the misrule of Herod. In three other renderings of the subject Steen depicts a child as 'king' (Museum of Fine Arts, Boston, dated 1662; County Museum of Art, Los Angeles, *c.*1666–7; and Staatliche Museen, Kassel, dated 1668).

For the present composition, acquired by George IV with the collection of Sir Francis Baring, Steen has seated the 'king' on the right in the hallway of a house, with his foot on a pair of bellows. He is flanked by a man dressed as a fool and a woman representing gluttony. At lower right a small girl hitches up her skirt to jump over the three candles symbolising the three magi. Waffles, as seen on the

plate in the foreground, were traditionally consumed during the course of celebrations and the broken eggshells and the frying pan being licked by the dog are related to this. At the top of the stairs on the left is a young man singing while playing a *rommelpot* (an earthenware pot half-filled with water covered with a stretched pig's bladder). He is part of a group of entertainers who wandered the streets singing and carrying a paper star (half-visible at the door) representing the biblical star that guided the three magi to Bethlehem. The artist has portrayed himself as the man holding up three clay pipes, positioned just above the seated woman feeding a child. Attached to the mantelpiece is a print of a monkey seated before an owl, which probably illustrates a Dutch proverb. Some aspects of the composition (for example, the boy in the foreground holding a golf club) remain unexplained and it is possible that Steen has introduced an additional moral significance to the narrative.

White, no. 190

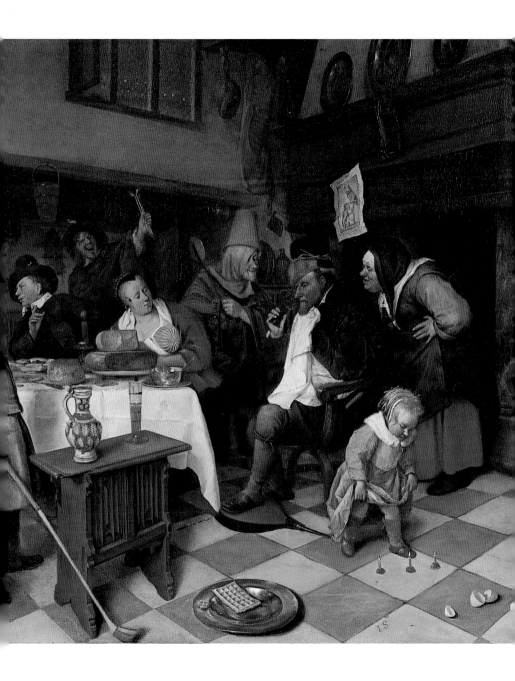

ADRIAEN VAN DE VELDE

(1636–1672)

A hawking party setting out

Oil on canvas
50.5 × 47.6 cm (19⅞₆ × 18¹¹⁄₁₆″)
Signed and dated lower left corner:
A.V. Velde f/1666
RCIN 406966

The artist, who was from Amsterdam, was the son of Willem van de Velde the Elder and the younger brother of Willem van de Velde the Younger (pages 165–9), both accomplished marine painters. He himself was predominantly a landscape artist who included beach scenes and winter scenes in his oeuvre. However, Adriaen van de Velde was an outstanding draughtsman and print maker who also undertook figure compositions of historical, mythological, religious and allegorical subjects, as well as portraits and genre scenes. He was frequently asked to paint the figures in other people's paintings, including artists of the calibre of Jacob van Ruisdael, Meyndert Hobbema and Jan van der Heyden. There is therefore a considerable diversity in his output which is not always acknowledged. It is likely that Adriaen van de Velde received his initial training from his father, but Jan Wynants (page 190) is cited as being his real master. Other painters were also relevant for his development – Paulus Potter (1625–54), Nicolaes Berchem and Philips Wouwermans. Both *A hilly landscape with hawking party* by Wynants and *The halt of a hawking party outside an inn* by Wouwermans are comparable in these respects with the present painting, which was in the Choiseul-Praslin collection in Paris at the end of the eighteenth century. At the beginning of the following century it was in the collection of Lord Rendlesham before being acquired by George IV in 1810.

Scenes of hunting denote social privilege; the woman riding side-saddle on a grey horse in particular wears clothes that suggest an exotic life-style and she has a demeanour appropriate to her status. Adriaen van de Velde painted only a small number of hunting scenes and it is likely that they were for a specific clientele.

As in all of the artist's landscapes, there is a clever use of light and colour to

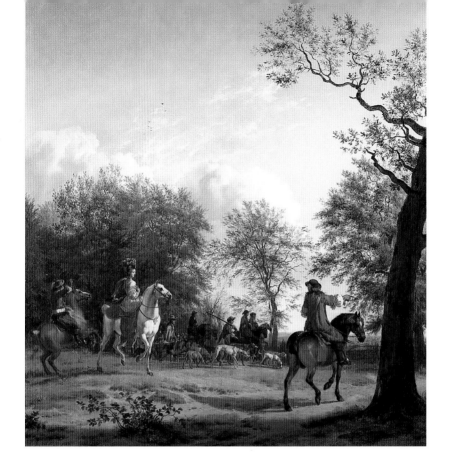

suggest atmosphere. Here the light comes from the right and highlights the female figure and her horse, but also picks out the sleek flanks of the dogs. The strong flow of movement towards the right is only halted by the tree trunk at the edge which frames the composition. The branches of this tree, together with the shadows cast on the ground, help to emphasise the sense of movement across the open ground of the clearing. The neat brushwork used for the foliage, the clouds and the soil has a softness of touch and delicacy that evoke the beneficence of nature.

White, no. 206

ADRIAEN VAN DE VELDE

(1636–1672)

Shepherd and shepherdess with cattle by a stream

Oil on canvas
64.7 × 77.4 cm (25½ × 30½")
Signed and dated above the group
of sheep on left: *A.V. Velde f./1668*
RCIN 404137

Arnold Houbraken wrote of the artist in 1721, 'He zealously drew and painted cows, bulls, sheep and landscapes and carried his equipment each day out to the countryside – a practice that he maintained until the end of his life once per week.' The result of such expeditions was a number of pastoral landscapes of striking beauty. These usually show nature in a becalmed state often tinged with a golden Italian light, which van de Velde need not necessarily have experienced at first hand but possibly observed in paintings by those who had visited the peninsula. There is an immense clarity in a composition that is actually fairly elaborate, but the artist has such control over the velvety smoothness of his brushwork, the purity of his colour and the application of aerial perspective that nothing seems forced or inappropriate. Partly this is because van de Velde prepared his compositions carefully with numerous drawings incorporating compositional and individual figure studies. The poses of the two figures in the present painting were clearly perfected in drawings done from models before painting began and there is a reassuring classical poise about them. The artist took similar care over the animals that appear in his pictures. In the same way, the reflections in the water help to anchor the central group.

The bucolic charm of these paintings where summer seems to be a permanent state was not without significance for painters of the Barbizon school in France during the mid-nineteenth century. Similarly, the coast scenes with their towering skies, fresh breezes, hazy light and moist atmosphere anticipate artists like Eugène Boudin (1824–98) with his depictions of Trouville in the 1860s. Adriaen van de Velde in fact could render nature in all its moods and

guises – winter, summer, calm, storm, sun, cloud. He frees the spirit and fills the viewer with feelings of well-being or, as one German writer expressed it, *Sonntagsstimmung* ('Sunday atmosphere').

 Shepherd and shepherdess was in Dutch collections during the second half of the eighteenth and early nineteenth centuries (Braamcamp, Doekscheer and Smeth van Alphen). It was acquired by George IV in 1811.

White, no. 208

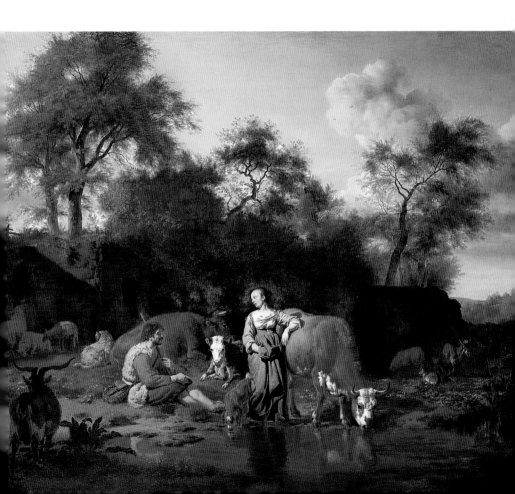

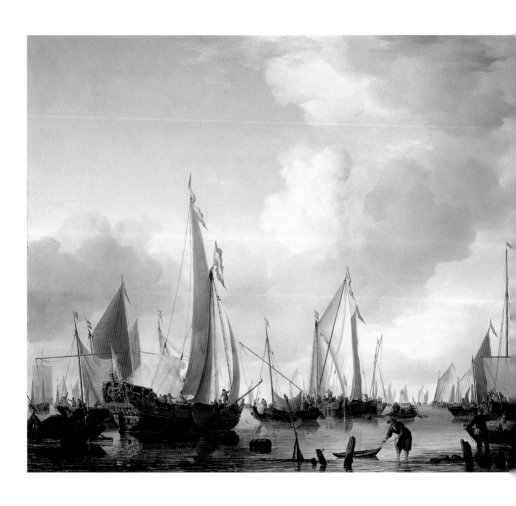

WILLEM VAN DE VELDE THE YOUNGER

(1633–1707)

A calm: a States yacht under sail close to the shore, with many other vessels

Oil on panel
59.6 × 71.2 cm (23⅞₆ × 28″)
RCIN 405328

On the left is a Dutch States yacht, a type of vessel used most often as a pleasure boat for carrying distinguished people – thus the large cabin aft. Apart from the coat of arms of the House of Orange supported by two lions visible on the stern, the Dutch flag is flown in three separate places – masthead, peak and stern. The yacht is viewed from abaft the starboard beam and is seen under sprit-sail and foresail in a light air on the port beam. She is firing a gun to port. The scene is viewed from the shore, where in the foreground a man hauls in a fishing-net. On the left is a *pont* (a flat lighter used for transport) loaded with hay or straw, while on the right there is another boat with a man sitting smoking. Some of the larger vessels in the middle distance are identifiable: in the centre a *kaag* (round-hulled clinker-built vessel with straight raking system) with sails lowered and two *smalschips* (transport vessels) alongside with sails set; and on the right a *hoeker*-rigged Rhine *aak* (barge) with her mainsail half-mast high and another *pont* with her sprit-sail set. The horizon is low and the picture is dominated by the towering sky. The influence of paintings by van de Velde's master Simon de Vlieger is apparent. It has been suggested that the figures in *A calm* were painted for the van de Velde studio by Hendrick Dubbels (1621–1707).

The date of the painting is *c*.1655; the States yacht appears in another picture in the Royal Collection, dated 1659, with a later rig involving a pole mast and shrouds and crossbeam to the top mast.

Examination of Willem van de Velde the Younger's paintings and drawings reveals a sureness of touch and exactitude of representation that make his works

totally absorbing. Different types of weather or the movement of the waves were only two aspects of each composition; another was the vessels themselves (hulls, rigging, sails) – both the technical details and the way in which individual boats behaved in varying conditions. As the artist himself noted on a drawing in the British Museum, 'There is much to observe in beginning a painting; whether you will make it mostly brown or mostly light; you must attend to the subject, as the air and the nature of its colour, the directions of the sun and wind, whether the latter be strong or moderate, are to be chosen as may seem best. Then the sketching of the ordnance or ships under sail...' When all these aspects are happily combined, what impresses most is the artist's control over the spatial intervals. The calculation of these intervals is not so much a matter of mathematics as an innate artistic ability comparable with musical composition. It is an aspect of van de Velde's work to which Piet Mondrian (fig. 10) might

have responded. Certainly John Constable was impressed by *A calm* and he made a copy of it in pencil. The painting was in the Smeth van Alphen collection in Amsterdam and was acquired by George IV with Sir Francis Baring's collection.

White, no. 212

WILLEM VAN DE VELDE THE YOUNGER
(1633–1707)

The 'Royal Escape' in a breeze

Oil on canvas
63.5 × 76.2 cm (25 × 30″)
Signed lower left corner: W.V.V.
RCIN 405211

The importance of the sea in Dutch life as the basis of empire and for the maintenance of trade is reflected in the number of marine artists active during the seventeenth century. Both Willem van de Velde the Elder and his son played a dominant role in the recording of ships and shipping over a number of years during which there were three Anglo-Dutch wars (1652–4, 1665–7 and 1672–4) fought at sea. The hub of Dutch marine activity was the harbour of Amsterdam and Willem van de Velde the Elder, who had been born in Leiden and was the son of a master of a transport vessel, settled his family in the city by 1636. There he trained his son, who was also a pupil for a time of Simon de Vlieger. The French invasion of Holland in 1672 made it difficult to earn a satisfactory living and both father and son moved to London (*c.*1672–3), where they remained for the rest of their lives – working from 1674 for Charles II and then for James II. A studio was established for them in The Queen's House at Greenwich. The royal appointment stipulated that the elder van de Velde was to make drawings of naval battles from the life, as he had been doing previously in Holland, and that his son was to make paintings based on these drawings. A number of works resulting from this agreement remain in the Royal Collection. Although Willem van de Velde the Younger painted some general seascapes at the start of his career, he soon began to concentrate on specific vessels and naval events. He was immensely prolific and, in addition to having his father's participation, he employed a number of assistants to paint replicas of his more popular compositions. The influence of the van de Veldes on British marine painting during the eighteenth century was profound.

The 'Royal Escape' in a breeze shows how skilfully Willem van de Velde the

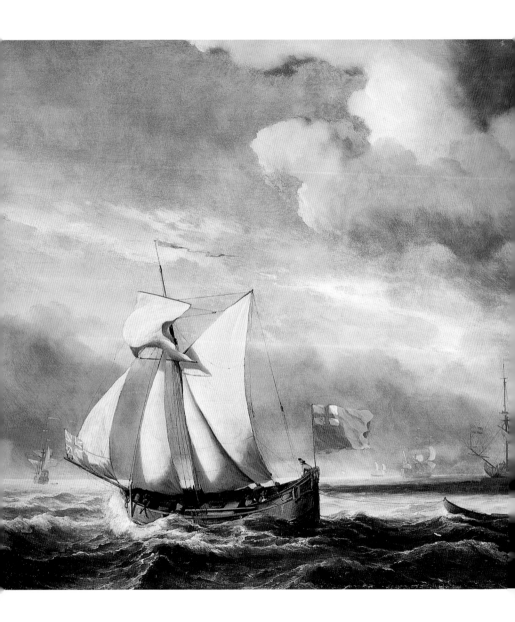

Younger could depict the effects of conditions at sea, with a stiff breeze, changing sunlight and choppy water, conditions quite different from those in *A calm*. This painting commemorates an incident in the flight of Charles II to France after his defeat at the Battle of Worcester by Oliver Cromwell in 1651. In the previous year the King had landed in Scotland in an attempt to regain his throne, but when the invasion ended in failure he went back to live on the continent until the Restoration in 1660. Charles II's escape after the Battle of Worcester became legendary and he subsequently commissioned paintings, such as the present example, to commemorate it.

The Royal Escape was a coal-brig built at Brighthelmstone (Brighton) and previously called *The Surprise*. She was owned by Francis Mansell and captained by Nicholas Tattersall. Charles II boarded near Shoreham on 15 October and landed at Fécamp, near Rouen. After the Restoration the King purchased the vessel and converted her into a smack-rigged yacht with the name of *The Royal Escape*. She usually moored at Whitehall until 1673, when she was handed over to the navy for general service and converted yet again into a smack of two guns. She was rebuilt in 1714. In this painting of *c*.1675 *The Royal Escape* is shown in a port broadside view close hauled on the starboard tack under mainsail, topsail, foresail and jib. She is flying the Red Ensign at the stern, the Union Flag at the bow and a pendant of a man-of-war at the masthead. A boat on a long line is astern.

Another depiction of *The Royal Escape* by Willem van de Velde the Younger is in the National Maritime Museum, Greenwich, as are several drawings showing the vessel at different stages of her various transformations.

White, no. 216

JOHANNES VERMEER

(1632–1675)

A lady at the virginals with a gentleman ('The Music Lesson')

Oil on canvas
73.3 × 64.5 cm (28¹¹⁄₁₆ × 25⅜")
Signed on the bottom of the frame of
the painting on the extreme right:
IVMeer (IVM in monogram)
RCIN 405346

The painting entered the Royal Collection in 1762 as a work by Frans van Mieris the Elder owing to a misreading of the signature. Indeed, the name of the artist was not correctly identified until 1866 by Théophile Thoré. During the late seventeenth century the picture had been in collections in Delft, Vermeer's home town, including that eventually sold on 16 May 1696 by Jacob Dissous who had twenty-one paintings by the artist – the largest group of such works assembled by a single individual. *A lady at the virginals* was subsequently acquired by the Venetian artist, Giovanni Antonio Pellegrini, in 1718 in either Amsterdam or The Hague. Pellegrini's collection was bought by Consul Joseph Smith, who in turn sold his own collection to George III. By such a route did one of the greatest Dutch pictures in the Royal Collection arrive and to a certain extent the initial oversight regarding its importance has been more than adequately compensated for by the amount of scholarly attention that it now receives.

Paintings by Vermeer – of which there are only thirty-four known – are difficult to date and any chronology has to be based on an interpretation of style and complexity of composition. *A lady at the virginals* was undoubtedly painted during the 1660s, but it is not possible to be more specific although there is at present a consensus of *c*.1662–4. The composition is characterised by the rigorous use of perspective to draw the eye towards the back of the room where the figures are situated – the young woman rather surprisingly seen from the back. The viewer is at first more aware of the jutting corner of the table, the chair and the bass viol than of the figures themselves, whose privacy is thereby protected. The back of the room, dominated by the virginals comparable with

those made by Andreas Ruckers the Elder (1579 – after 1645), is like a grid of verticals and horizontals into which the figures are carefully locked. Light is admitted through the windows on the left and fills the room, casting only soft, subtle shadows. A striking feature of the composition in this part is the mirror on the wall where the slightly blurred reflections include the young woman's face, part of the table and the legs of an artist's easel. The implication of this glimpsed easel is that Vermeer shares the same space as the figures he is depicting, but as a result of this artifice he is also, like the viewer, standing outside that space. In fact, as Alpers has observed, Vermeer's composition is based on exclusion. Many of the elements, particularly at the back of the room, are seen only partially, as though indicating 'the appearance of the world as ungraspable'.

The greatness of Vermeer is derived from an economy of means verging on the enigmatic – an enigma that pertains to Vermeer's life as much as to his art. The viewer feels at once invited and yet excluded, just as the artist's technique appears to be seductively simple but is in fact awesomely intricate in its application of paint and choice of colour. Similarly, writers can readily search for meanings in Vermeer's paintings, but rarely find answers even though clues are provided. As was written by Lawrence Gowing in 1952, there is in Vermeer's pictures a 'studied obliquity of theme'.

The inscription on the lid of the virginals, LETITIAE CO[ME]S / MEDICINA DOLOR[IS], means 'Music is a companion in pleasure and a balm in sorrow'. It suggests that it is the relationship between the man and the young woman that is being explored by the artist, but what stage that relationship has reached is impossible to say. The fact that there are two musical instruments implies shared pleasures and a potential harmony, which is also indicated by the rapt expression on the man's face as he listens to the young woman or sings as she plays on the virginals. That some aspect of love is the presiding theme can be deduced not only from paintings by Vermeer's contemporaries, such as Metsu, but also by the presence in A lady at the virginals of the picture of Roman Charity (Cimon and Pero) by Dirck van Baburen (c.1595–1624) on the wall in the background on the

right. This is the story of how the imprisoned Cimon was nourished by his daughter Pero, symbolising the ideal of Christian charity both physically and spiritually. It is known that Vermeer's mother-in-law, Maria Thins, owned such a painting and Vermeer did use another painting by this artist in the background of two of his other pictures. The vase on the table is placed below *Roman Charity* and so with regard to that picture may be an additional correlative for the young people in the room.

The mood of the present interior by Vermeer is created as much by the careful selection of so few objects as by the confrontation of the two figures in whose plight, in the words of Lawrence Gowing, 'there rests, as gentle as the air itself, an allegory of liberty and bondage, an allegory, as the inscription informs us, of the pleasure and melancholy of love'.

White, no. 230

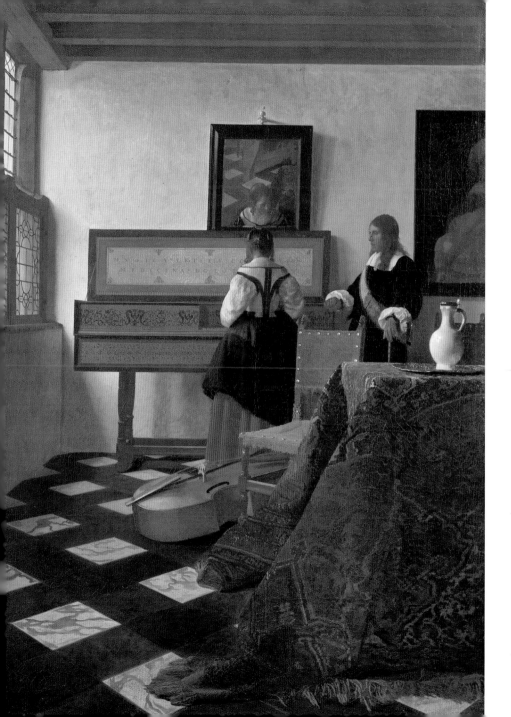

JAN WEENIX

(1642–1719)

Dead hare with partridges
with instruments of the chase

Oil on canvas
118.7 × 91.4 cm (46¹¹/₁₆ × 36″)
Signed and dated on side of slab of stone
lower right: *J. Weenix.f.1704*
RCIN 403375

The son of Jan Baptist Weenix, a landscape painter who while in Rome 1642–7 worked for Cardinal Giovanni Battista Pamphili (later Pope Innocent X), the artist was trained in Utrecht, although from 1679 he lived for the rest of his life in Amsterdam. Jan Weenix told Arnold Houbraken that his father was an immensely fast worker who could paint three life-size half-length portraits in a single day, but even if he did not share his father's prestidigitatorial skills he painted similar subjects – dead game, Italianate scenes, some portraits and genre themes. Like Adriaen van der Werff (pages 177–9), Jan Weenix was court painter (*c*.1702–14 or longer) to the Elector Palatine, Johan Wilhelm, in Düsseldorf, for whom he made a series of twelve paintings of live and dead game for Schloss Bensberg (now in the Alte Pinakothek, Munich). His other aristocratic patrons included Lothar Franz Schönborn (1655–1729), Prince Bishop of Bamberg and Archbishop and Elector of Mainz, at Pommersfelden and Gaibach. Some of his paintings, such as *Landscape with a huntsman and dead game* ('*Allegory of the Sense of Smell*') of 1697 in the National Gallery of Scotland, Edinburgh, are on a very large scale, and were clearly meant to decorate whole walls.

Jan Weenix specialised to a greater extent than his father in painting hunting-trophy pictures. As a theme the tradition was stronger in Flemish art, with painters such as Frans Snyders (1579–1657), than in Dutch art, simply because in Holland hunting in whatever form was not such a popular pastime. The compositions devised by Weenix are elaborate, involving not only dead game but the instruments of the chase – bags, cartridges, whistles, nets, snares, knives and rifles – and extensive settings in parklands or spacious gardens with sculpture or

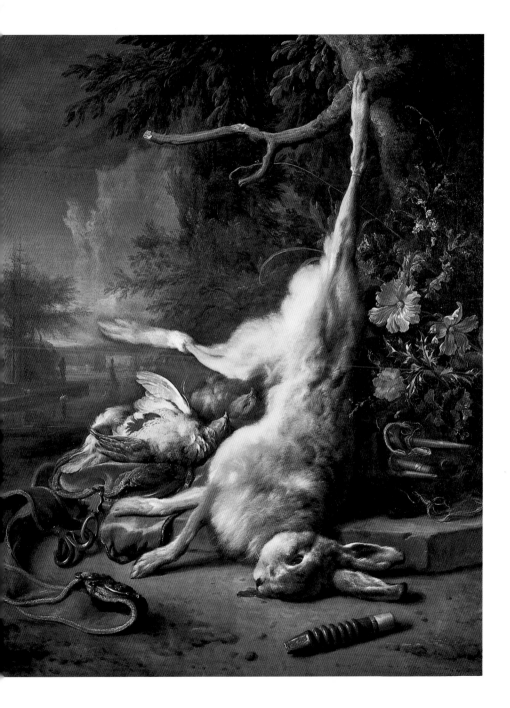

ornamental urns. Although no country house is shown in *Dead hare*, which was acquired by George IV with Sir Francis Baring's collection, the garden with statuary and water suggests a large country estate. There is often a mournful air over the proceedings in these pictures: the encroaching twilight, dead animals, an absence of humanity and only the flowers or the trees to remind the viewer of the beauty of living nature, but even these aspects are of course transitory.

The dead hare was one of the artist's oft-repeated motifs: in 1704 alone, for example, it also occurs dominantly in *Dead hare, fruit and monkey* in the Wallace Collection, London, and *A monkey and a dog beside dead game and fruits* in the Rijksmuseum, Amsterdam. In many respects such pictures herald those by the French painters Jean Baptiste Oudry (1686–1755) and Jean Baptiste Chardin (1699–1779) in the eighteenth century.

White, no. 299

ADRIAEN VAN DER WERFF

(1659–1722)

A boy and a girl with a guinea pig and a kitten

Oil on canvas
33.9 × 27.3 cm (13⅜ × 10¾")
Signed and dated on the parapet
(now indistinctly): *A. V. WERFF fe. 1681*
RCIN 404625

For his contemporaries Adriaen van der Werff was the greatest of all Dutch painters and his works commanded higher prices than those by Rembrandt. His reputation remained intact until the middle of the nineteenth century. Although he also practised as an architect, his personal fortune was made by the sale of his paintings. Born near Rotterdam, he trained first with Cornelis Picolet (1626–79) and then, more significantly, with Eglon van der Neer (1634?–1703). He was already an independent master by the age of 17 and in 1690–91 was elected a principal member of the Guild of St Luke in Rotterdam. He was resident in Rotterdam for most of his life, even though his main patron, the Elector Palatine, Johan Wilhelm, in Düsseldorf, appointed him court painter in 1697 with an annual salary of 4,000 guilders on condition that he painted exclusively for the Elector for six months of the year. Van der Werff visited Düsseldorf several times to deliver pictures and was knighted in 1703, whereupon his commitment was increased to nine months a year. He also worked for other royal patrons, including Augustus, Elector of Saxony and King of Poland, and Duke Anton Ulrich of Brunswick-Wolfenbüttel. At the beginning of his career the artist adopted the style of the *fijnschilders* in Leiden with its emphasis on detail, but in his maturity he perfected such a high degree of finish that the surface of his paintings sometimes resembles enamels. For his aristocratic patrons he worked in a more refined figurative classical style, specialising in mythological and religious subjects as opposed to genre. Knowledge of the important collections formed by Nicolaes Flinck (1646–1723) in Rotterdam and Jan Six (1618–1700) in Amsterdam, as well as of the classicising paintings of Gérard de Lairesse

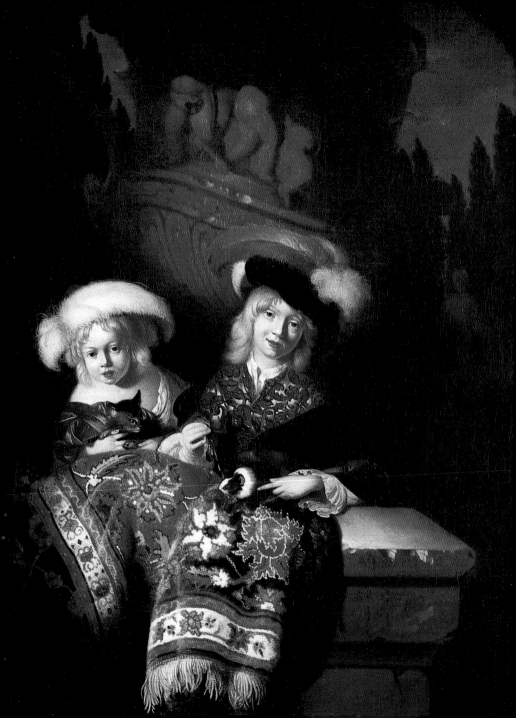

(1641–1711), provided him with a firm basis for exploring the traditional themes of art. There is also a pronounced element of French classicism in van der Werff's work that dilutes his true Dutch inheritance.

The two children in the present picture, which was acquired by George IV with Sir Francis Baring's collection, are in fancy dress and are depicted in a garden. They are positioned behind a stone parapet over which a carpet has been placed. A classical urn decorated with putti is in the background. The child on the left holds a cat and that on the right indicates a guinea pig. Although cats are an attribute of childhood, since both exhibit similar patterns of behaviour, here it is the interaction between the cat and the guinea pig that is important. The boy on the right holds a watch, the cord of which is being bitten by the guinea pig. It is this that perhaps attracts the cat's attention, quite apart from its natural instinct to attack the guinea pig. Possibly there is a symbolic meaning in what at first sight appears to be a scene of two children playing with their domestic pets, and that meaning might have amorous connotations for the viewer when removed from the context of innocence. Children as the subject of paintings is a theme essayed by Frans Hals and the painters he influenced, but it was van der Werff who painted them with their pets, thereby anticipating a trend fully developed in the eighteenth century.

White, no. 302

ADAM WILLAERTS

(1577–1664)

The embarkation at Margate of the Elector Palatine and Princess Elizabeth

Oil on canvas
121.9 × 196.9 cm (48 × 77½")
Signed and dated on the plank in the centre foreground: *A Willarts fe 1623*
RCIN 404994

The painting, acquired in 1858 by Queen Victoria, records a particular incident, namely the departure of the Elector Palatine (later Frederick V of Bohemia) and Princess Elizabeth (later known as the Winter Queen) from Margate in Kent on 25 April 1613. The marriage of Princess Elizabeth, the daughter of James I and his wife Anne of Denmark, to the Elector Palatine had taken place in London in February 1613. The bride's elder brother, Henry, Prince of Wales, had died on 6 November 1612, and her younger brother, Charles, became king in 1625. She bore thirteen children, but spent most of her life in exile after Frederick V was defeated by the Holy Roman Emperor at the Battle of the White Mountain in November 1620 and lost his throne. He died in 1632 and for thirty years after that until her own death in 1662 the Winter Queen resided in The Hague and London.

The departure from Margate was delayed several times as a result of bad weather. The formal farewells on the landing stage known as Kings Stairs are shown in the right foreground, possibly in the presence of James I (at left in a dark suit and hat) and Anne of Denmark (amongst the ladies on the right). Royal barges ply their way between the shore and the waiting vessels. Chief of these is the *Prince Royal*, flying the royal standard at the main mast and originally commissioned by Henry, Prince of Wales. This was the first three-decker ever built for the English navy and the largest ship constructed during the reign of James I. It was designed by Phineas Pett and launched on 24 September 1610. The vessel sailing on the same tack as the *Prince Royal* on the left of the composition may be the *Phoenix*, also designed by Pett and launched on

27 February 1613. Margate is in the background on the right, with windmills on the skyline and a smoking lime kiln prominent on the shore.

Willaerts painted *The embarkation at Margate* exactly ten years after the event, by which time the fortunes of Frederick V and Princess Elizabeth had changed for the worse. Another version of the scene at Dover, slightly smaller and less elaborate, is in the National Maritime Museum, London: it is signed and dated 1622. Willaerts also depicted *The arrival of the Elector Palatine at Flushing on 29 April 1613* (London, National Maritime Museum) in the same year as *The embarkation at Margate*. There is no explanation as to why paintings of these particular events were undertaken so long after the event, although the artist had an established reputation for mannerist seascapes of this type. He originally came from Antwerp, which his family probably left after the fall of the city to the Spanish in 1585. After spending a few years in London, Willaerts arrived in Utrecht at the turn of the century.

White, no. 235

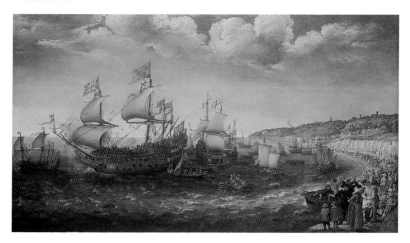

Adam Willaerts, *Embarkation of the Elector Palatine in 'The Royal Prince'*, 1622
(National Maritime Museum, London)

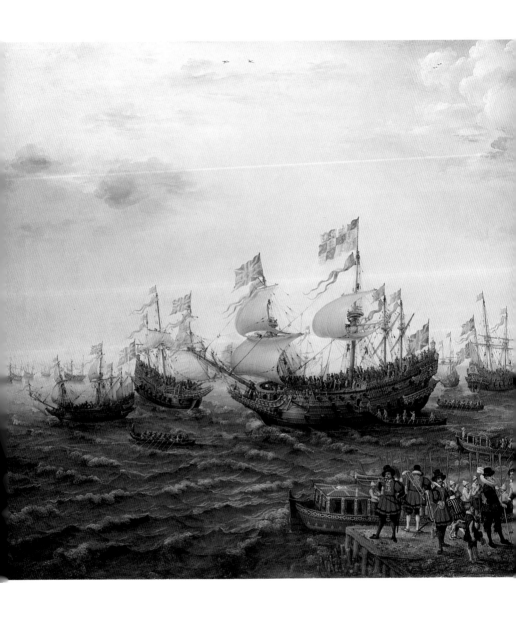

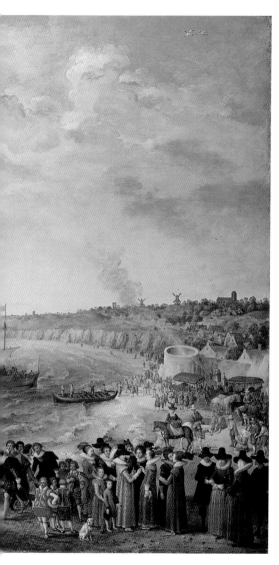

PHILIPS WOUWERMANS

(1619–1668)

The halt of a hawking party outside an inn

Oil on panel
57.8 × 62.2 cm (22 ¼ × 24 ½")
Signed lower left corner:
PHW (in monogram)
RCIN 406736

Philips Wouwermans was an immensely successful painter during his own lifetime and died a rich man. His reputation increased even more during the eighteenth century, when French aristocratic collectors added numerous examples of his work to their collections.

Wouwermans was the son of a painter and his brothers, Pieter and Jan, were also artists. He spent all his life in Haarlem, apart from two years in Hamburg (1638–40) as the result of a family dispute over his marriage to a Catholic woman. Having returned to Haarlem, he became a member of the Guild of St Luke and began a prolific output of landscapes with genre figures, but also military and hunting scenes. His reputation for the most part rested on his skill as a painter of equestrian themes. He also contributed staffage figures to paintings by other artists such as Jacob van Ruisdael and Jan Wynants. There is, however, no clear pattern to his development as an artist. Presumably his father was a formative influence, but a contemporary source says that he was trained by Frans Hals. While in Hamburg he was said to have worked with Evert Decker (d.1647) and it is often stated that his figure style owes a great deal to Pieter van Laer ('Bamboccio'), who had returned to Haarlem from Rome in 1638 and some of whose work Wouwermans owned. It is possible that from this source the Italianate aspects of his style, such as the treatment of light, were derived. His earliest dated work is of 1639, but there are not many other dated paintings and so the exact chronology of his oeuvre is uncertain.

The halt of a hawking party is a characteristic example of Wouwermans's treatment of subject-matter and style. The painting was in the Jan Gildemeester

and the Smeth van Alphen collections in Amsterdam at the beginning of the nineteenth century. It was purchased by George IV in 1811. The mixture of classes – the elegant company on horseback, the servants from the wayside inn on the left and the gypsy woman with her child on foot trying to catch the attention of the man with the hawk – provides a cross-section of society as it makes its way through the Dutch countryside. There is an atmosphere of intense activity in Wouwermans's paintings. People are always on the move: the small figures are like puppets with jerky actions and hands and limbs at odd angles. But, at the same time, the artist is a wonderful technician and, like many of his pictures, *The halt of a hawking party* is memorable for its lightness of touch, delicacy of colour and control over incidental detail. The couple on grey horses hold the centre of the composition, but from that point the eye is led outwards in several directions as though along the spokes of a wheel acting like a centrifugal force. The silvery tone also creates a rippling surface that generates a further sense of perpetual motion like the changing light on a cloudy day.

White, no. 242

PHILIPS WOUWERMANS

(1619–1668)

Cavalry at a sutler's booth

Oil on panel
49.5 × 44.4 cm (19½ × 17½")
Signed lower right corner:
PHILS. (in monogram) *W.*
RCIN 404615

This was one of the artist's most popular military subjects – comparable, for example, with a painting of a similar scene, *Cavalrymen halted at a sutler's booth*, in the National Gallery, London: both probably date from the 1650s. There is an elaborate preparatory drawing for the present painting in the British Museum, an unusual occurrence in the artist's oeuvre. The painting was imported into Britain at the beginning of the nineteenth century and bought by George IV in 1812.

Paintings by Wouwermans are notable for the amount of detail that he manages to pack into his compact compositions. The activity around the tents dominates the middle distance, but the eye is led by the diagonal emphasis into the left background where other figures are seen approaching. Sutlers provided provisions for an army on the move and were essentially camp-followers. This explains the gypsy-like atmosphere of the scene – mothers with children and beggars. The principal figures are the three on horseback: one blows a trumpet (on the left), another raises a glass (in the centre) and the third fires a pistol (on the right). In the centre foreground, prominently positioned although half in shadow, a dog defecates.

The nature of the subject-matter is almost in direct contrast with the sophistication and delicacy of the technique. Wouwermans's neat brushwork, subtle touches of colour and vivid treatment of light are all seen at their best in *Cavalry at a sutler's booth*, but the artist's greatest skill perhaps lies in the silvery tone that envelops the whole composition and in the atmosphere that suggests the feeling of being outside on a windy day with rain in the air.

The painting was engraved for Jean-Baptiste Pierre Le Brun's *Galerie des Peintres Flamands, Hollandais et Allemands* (3 vols., 1792 and 1796). It appears in

Vol. 2 as pl. 53b with the title *Le Coup de Pistolet* and serves to demonstrate the popularity of Wouwermans's paintings in France during the eighteenth century. For French collectors the artist's style seemed to anticipate the rococo in its lightness and delicacy of touch. This is more or less where Watteau starts. Le Brun's publication was a lavish sale catalogue amounting to a corpus of paintings of the northern European schools, which he did so much to promote in France before and after the French Revolution.

White, no. 245

JAN WYNANTS

(1631/2–1684)

A hilly landscape with hawking party

Oil on panel
45.4 × 55.6 cm (17⅞ × 21⅞")
RCIN 400940

Wynants was a prolific landscape painter who was inspired by the dunes that were such a feature of his birthplace, Haarlem, and its surrounding districts. The sandy terrain, gnarled trees, stagnant pools, rutted tracks and undulating hills are the constituent elements in his pictures. Frequently, the figures that occur were painted by different hands, usually Johannes Lingelbach, or Adriaen van de Velde (pages 160–63), who was at one time a pupil of Wynants. There is also evidence of the influence of Philips Wouwermans and of Jacob van Ruisdael on Wynants. Towards the end of his life, rather like Cuyp, the Dutch landscape in his works could take on the golden glow of Italy. The only two exceptions to the landscapes in Wynants's output are the street scene *View of the Herengracht, Amsterdam* (Museum of Art, Cleveland) painted *c*.1660–62 and *Vertumnus and Pomona* (present whereabouts unknown) of 1679.

Although Wynants is closely associated with Haarlem, he in fact lived in Amsterdam from 1660. His father had been an art dealer and Wynants himself is described as a 'painter and innkeeper'. He always seems to have been in straitened financial circumstances even though he was so prolific: occasionally, he appeased creditors with *een soopie brandeswijn* (a little brandy), thereby neatly combining all aspects of his life.

A hilly landscape is undated, but was probably painted during the mid-1660s. It remained in Dutch collections until the early nineteenth century and was acquired by George IV in 1810. It is comparable, for example, with *A track by a dune with peasants and a horseman* in the National Gallery, London, of 1665, or *Sportsmen in the dunes*, of 1669, in the Royal Collection. In a strictly

topographical sense Wynants's landscapes record countryside that has disappeared through erosion or reclamation, but it is more the atmosphere exuded by these pictures that makes them so compelling. The air is clear and refreshing, the light soft and, even if some of the trees are dead, there is always a sense of man living in harmony with nature and a feeling of well-being in simply being outside on a beautiful day. Not surprisingly, landscapes by Wynants were an early influence on Thomas Gainsborough, who saw examples of his work in British collections in the mid-eighteenth century.

White, no. 263

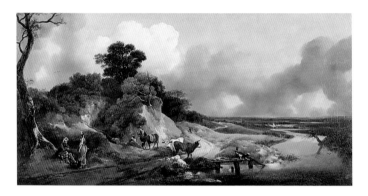

Thomas Gainsborough, *Landscape with a view of Cornard village*, c.1748–50
(National Gallery of Scotland, Edinburgh)

FURTHER READING

Historical background

J. Israel, *The Dutch Republic. Its Rise, Greatness and Fall 1477–1806* (paperback edition with corrections, Oxford, 1998)

General introductions

S. Slive, *Dutch Painting 1600–1800* (Pelican History of Art, New Haven and London, 1995)

W. Stechow, *Dutch Landscape Painting in the Seventeenth Century* (London, 1966)

M. Westermann, *A Worldly Art. The Dutch Republic 1595–1718* (London, 1996)

Other general books

S. Alpers, *The Art of Describing. Dutch Art in the Seventeenth Century* (Chicago, 1983)

M. Hollander, *An Entrance for the Eyes. Space and Meaning in Seventeenth-century Dutch Art* (Berkeley, Los Angeles, London, 2002)

J.M. Montias, *Artists and Artisans in Delft: A Socio-economic Study of the Seventeenth Century* (Princeton, 1982)

J.M. Montias, *Vermeer and his Milieu: A Web of Social History* (Princeton, 1989)

K. Muizelaar and D. Phillips, *Picturing Men and Women in the Dutch Golden Age. Paintings and People in Historical Perspective* (New Haven and London, 2003)

H.R. Nevitt, *Art and the Culture of Love in Seventeenth-century Holland* (Cambridge, 2002)

S. Schama, *The Embarrassment of Riches. An Interpretation of Dutch Culture in the Golden Age* (London, 1987)

Catalogues of some permanent collections

I. Gaskell, *Seventeenth-century Dutch and Flemish Painting. The Thyssen-Bornemisza Collection* (London, 1990)

J. Ingamells, *The Wallace Collection. Catalogue of Pictures Vol. IV. Dutch and Flemish* (London, 1992)

N. MacLaren (revised and expanded by C. Brown), *The Dutch School 1600–1900, National Gallery, London* (London, 1991)

P.C. Sutton, *Dutch and Flemish Seventeenth-century Paintings. The Harold Samuel Collection* (Cambridge, 1992)

A.K. Wheelock, *Dutch Paintings of the Seventeenth Century, National Gallery of Art, Washington* (Washington, 1995)

C. White, *The Dutch Pictures in the Collection of Her Majesty The Queen* (Cambridge, 1982)

C. White, *Later Flemish Pictures in the Collection of Her Majesty The Queen* (forthcoming)

Catalogues of recent exhibitions (artists)

Frans Hals
(London and Washington, 1989)

Johannes Vermeer
(Washington and The Hague, 1995–6)

Jan Steen Painter and Storyteller
(Washington and Amsterdam, 1996–7)

*Gerrit Dou 1613–1675. Master Painter in
the Age of Rembrandt*
(Washington, London and The Hague,
2000–2001)

Vermeer and the Delft School
(New York and London, 2001)

Major exhibitions (thematic)

Art in Seventeenth-century Holland
(London, National Gallery, 1976)

*Masters of Seventeenth-century Dutch
Genre Painting* (Philadelphia, Berlin,
London, 1984)

*Masters of 17th-century Dutch Landscape
Painting* (Amsterdam, Boston, Philadelphia,
1987)

*Images of a Golden Age. Dutch Seventeenth-
century Paintings* (Birmingham, 1989)

Dutch Art and Scotland. A Reflection of Taste
(Edinburgh, 1992)

*Masters of Light. Dutch Painters in
Utrecht during the Golden Age*
(San Francisco, Baltimore, London, 1997–8)

*The Glory of the Golden Age. Dutch Art of
the 17th Century. Painting, Sculpture and
Decorative Art* (Amsterdam, 2000)

All the publications listed above have
additional bibliographies.

ACKNOWLEDGEMENTS

I am grateful for the help and enthusiasm of my colleagues Jacky Colliss Harvey, Joanna
Brooks and Janice Sacher in the preparation of this book. Bob Bradley of Margate Old Town
Hall and Local History Museum provided information about the painting by Adam Willaerts.

INDEX